GLOUCESTER, TEWKESBURY & SEVERN VALE PUBS

THROUGH TIME

Geoff Sandles

AMBERLEY PUBLISHING

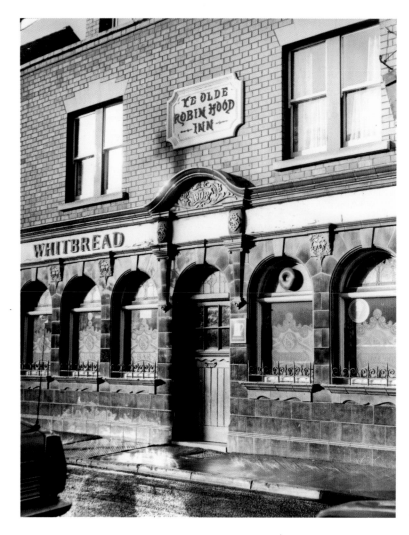

Ye Olde Robin Hood,
Hopewell Street,
Gloucester

First published 2013

Amberley Publishing
The Hill, Stroud
Gloucestershire, GL5 4EP

www.amberley-books.com

Copyright © Geoff Sandles, 2013

The right of Geoff Sandles to be identified as the
Author of this work has been asserted in accordance
with the Copyrights, Designs and Patents Act 1988.

ISBN 978 1 4456 0402 2

British Library Cataloguing in Publication Data.
A catalogue record for this book is available from
the British Library.

Typeset in 9.5pt on 12pt Celeste.
Typesetting by Amberley Publishing.
Printed in the UK.

Introduction

Gloucester, Tewkesbury & Severn Vale Pubs Through Time is the sixth and final book in my series looking at pubs in Gloucestershire, past and present. Previous books have explored the inns of the Cotswolds, the Forest of Dean, the Stroud Valleys and the Regency town of Cheltenham. There were areas of the county that were not represented in my other books, notably the pubs around Tewkesbury, the City of Gloucester, and the Vales of Berkeley and Gloucester. For the purposes of this title I have used the River Severn as a convenient reference point, from the confluence with the River Avon at Tewkesbury to the wider expanses of the Severn near Sharpness as it flows towards the Bristol Channel. Observant readers will question, with some justification, the inclusion of the Fleet Inn on the River Avon in Twyning, and some suburban pubs in Gloucester. There are also no pubs included on the western side of the Severn, these being included in the Forest of Dean selection. Perhaps the book should have been called *M5 Corridor Pubs in Gloucestershire Through Time*, although that's hardly a catching title.

When the Gloucester & Berkeley Canal was completed in 1827, the City of Gloucester became an important inland port. Prior to this, navigation on the River Severn was entirely dependent on the spring tides, which meant sailors were often laid idle in Gloucester for long periods of time, waiting to set sail. Around the Quay, many inns and taverns were established to cater for the voracious thirsts of these seamen. On the Quay itself stood the Star, the Mermaid, the Ship and the Salmon. Westgate Street also had an abundance of pubs.

If you think binge drinking is a curse of society today, consider the reports in the *Gloucester Journal* from 1870 about the Bunch of Grapes in Westgate Street, which was said to be frequented by 'sailors, unfortunates and women of a certain type'. Similarly, the Ducie Arms in Longsmith Street had its fair share of trouble, being 'frequented by women of bad character … and that drunken persons were seen coming out at closing time, that there was filthy language, fighting, general disorderly behaviour and indecency outside'. Considering that the average price for a pint was 2d (in old money), and the typical alcohol content of beer was 5½ per cent, perhaps it is no wonder that it was 'party time'.

Westgate Street now has five pubs: the Union, the Fountain, the Westgate, the Old Crown and the Dick Whittington. The sudden closure of the Pig Inn the City (previously the Lower George Hotel) in October 2011 was mourned by the Gloucester branch of the Campaign for Real Ale (CAMRA), as it had been their 'City Pub of the Year' for three years, selling consistently good and interesting ales. The tenant landlord could not persuade the owners, a property company, to invest in the fabric of the building, which was rapidly deteriorating. It was feared that there was a hidden agenda and the building was being deliberately run down in order to seek permission for change of use. At the time of writing the building stands unoccupied with an uncertain future – a tragic loss of a good pub.

There have been other pub closures in Gloucester in recent years that have been lost without any significant protest. The Chequers in Painswick Road was knocked down and a housing development stands on the site, and the Olde India House in nearby Barton Street was demolished in 2013 to make way for a mini-supermarket. A Tesco Express has already opened in what used to be the Welsh Harp in London Road. A Chinese restaurant operates in the old Bristol Hotel in Bristol Road, and the Black Swan, Park End and Seymour Hotel are now flats.

Countryside pubs are also closing at an alarming rate. As this book was being prepared I heard news that the Red Lion at Arlingham had closed (hopefully only temporary), and other pubs are struggling in these difficult economic times. A glimmer of hope was given to the pub trade in the Spring Budget 2013, when the Chancellor of the Exchequer abolished the hated Beer Duty Escalator, which automatically saw the duty on beer increase every year by 2 per cent above inflation. George Osborne even knocked a penny of a pint as an unexpected bonus.

After a miserable wet summer in 2012 and a dreary cold start to spring in 2013, pubs in the Gloucester and Severnside area certainly need a boost. Let's hope for a long and hot summer.

I am grateful to those people who have kindly contributed photographs. In these days of digital images of archive photographs it is sometimes difficult to source the original provider and I apologise if any of the selection have been reproduced without permission. Unfortunately, I have had no luck in tracing the very kind man who gave me so many original photographs of Gloucestershire pubs a few years ago. I owe him a huge thank you. I would also like to acknowledge Paul Best, Annie Blick, Clapham Facebook Group, John Hamblett, Dave Hedges, Neil Herapath, Darrel Kirby, *Dursley Gazette*, *Gloucestershire Echo*, Duncan Laker, Christine Maynard, Kathryn Molloy, Sue Mills, Steve Moth, Michael Wilkes and, last but not least, my wife Kathy, who has been so patient and understanding during the preparation of not just this book but the five others in the series.

Geoff Sandles
www.gloucestershirepubs.co.uk

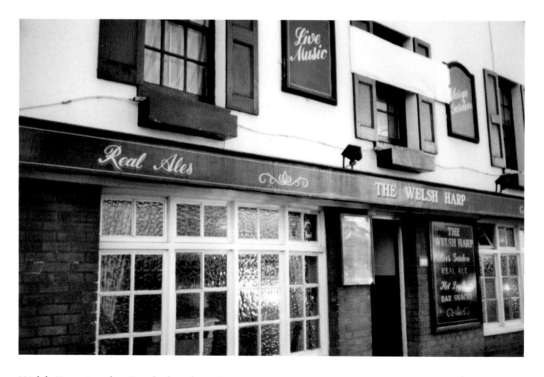

Welsh Harp, London Road, closed 2008

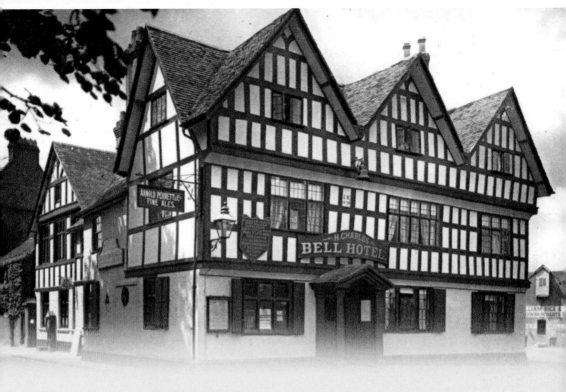

CHAPTER 1

Downstream From Tewkesbury

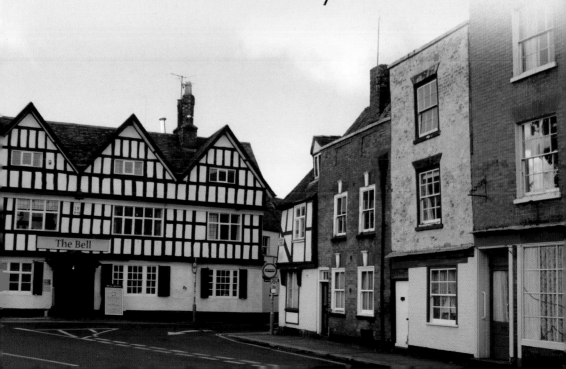

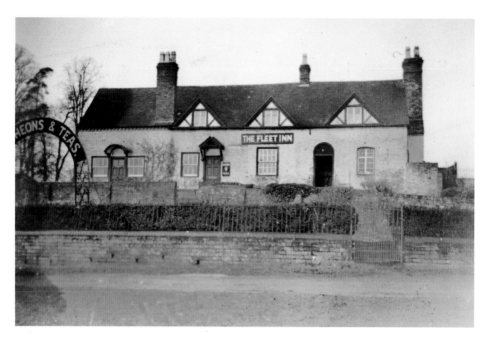

Fleet Inn, Twyning

The fifteenth-century Fleet Inn is located on the banks of the River Avon, 2 miles upstream from Tewkesbury. In Edwardian times, a makeshift ferry was employed to carry motor vehicles across the Avon – a risky venture as apparently the ferry sometimes sank under the weight of the cars! Indeed, the Fleet Inn has had its fair share of misfortune. The riverside moorings were swept away in the devastating floods of July 2007 and, following a £750,000 refurbishment, an electrical fire caused significant damage in June 2012.

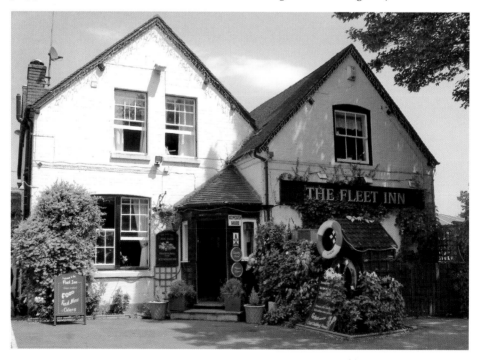

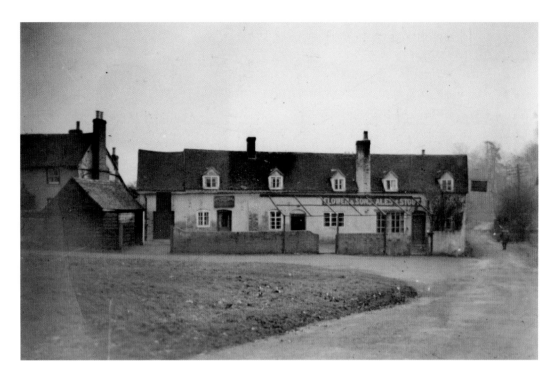

Village Inn, Twyning

The regulars at the Village Inn have raised considerable amounts of money for charity over the years. In November 1990 the pub's football team helped raise cash for a guide dog. A cricket match in July 2009 was in aid of Cancer Research, in honour of former landlady May Spurway who died in February 2008. The most spectacular – and noisy – charitable event at the Village Inn was the invasion of 600 bikers in August 2010, who raised £180 for the Midlands Air Ambulance.

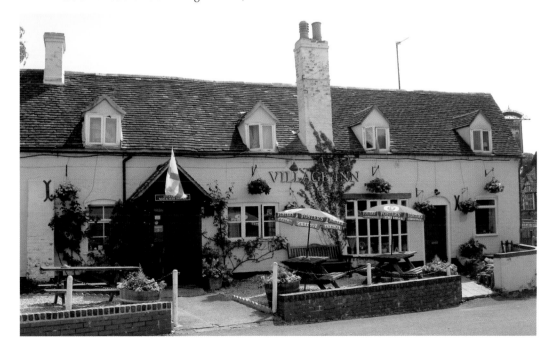

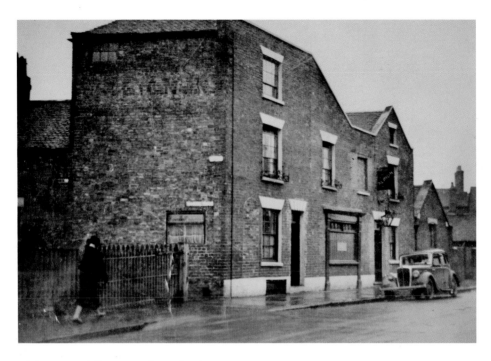

Albion Inn, Oldbury Road, Tewkesbury

The Albion has been providing entertainment of different sorts for many years. An advertisement from the late 1930s, when long serving licensee Florence Mary Maynard was still pulling pints at the pub, stated that the Albion was 'the house with the organ and two pianos'. At the beginning of the twenty-first century, the pub claimed that it was 'Tewkesbury's top entertainment for the over 25's' featuring a succession of live tribute acts and bands.

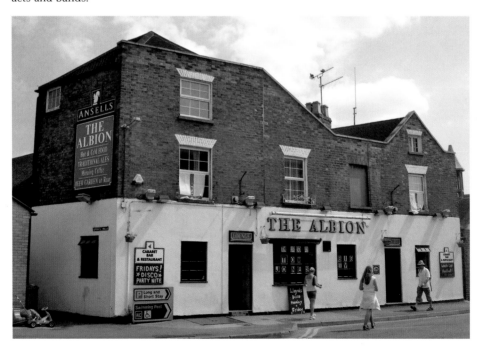

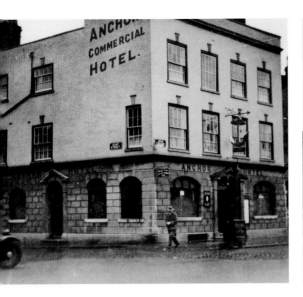
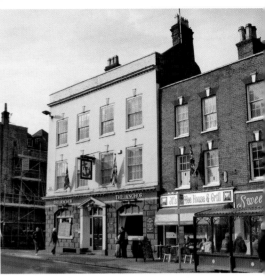

Anchor Hotel, High Street, Tewkesbury

The Anchor first opened in 1774 as a coaching inn. It was extensively remodelled by the Cheltenham Original Brewery in 1921. A late 1980s 'improvement' by Whitbread saw the removal of the public and lounge bars to create an open-plan drinking space. Rich mahogany bar fittings, large mirrors and decorative etched glass were ripped out. Even the heavy, gilded anchor that hung above the front door was replaced with a bland pictorial sign bearing the new identity of Greens. Thankfully, a makeover in 1996 saw the reinstatement of the original name.

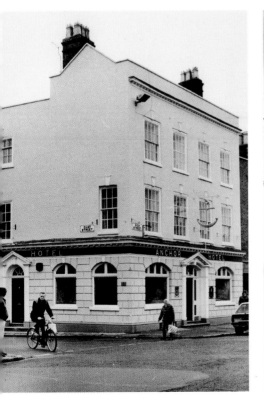
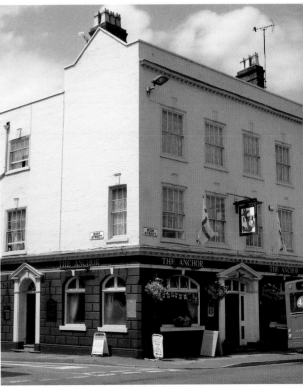

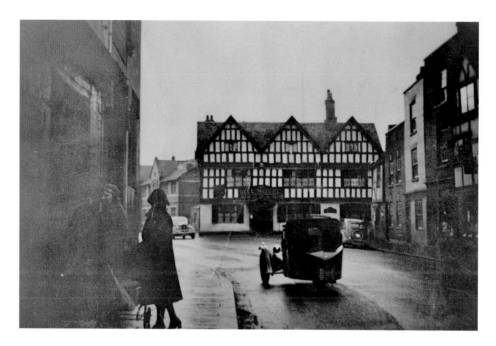

Bell Hotel, Church Street, Tewkesbury

The date 1696 inscribed over the front door of the half-timbered, triple-gabled Bell Hotel may refer to a time of renovation work at the Bell and it is likely that the inn was trading before that date, perhaps providing sustenance and accommodation to pilgrims visiting Tewkesbury Abbey directly opposite. Indeed, the inn was originally known as the Angel. In 1830, it was recorded as the Bell and Bowling Green Hotel. The Tewkesbury Bowling Club was established here in 1928 but moved to their present site in Gander Lane in 1975. Houses have since been built on the bowling green.

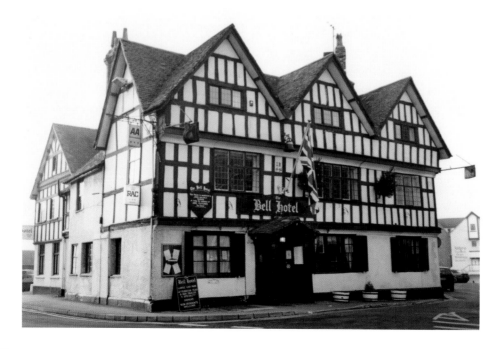

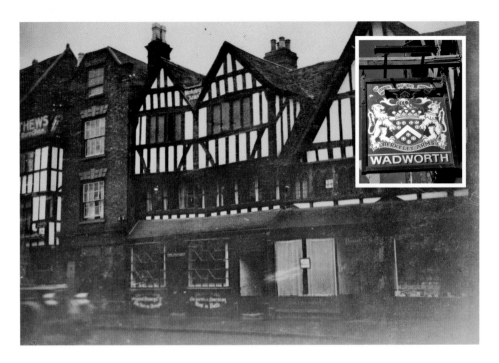

Berkeley Arms, Church Street, Tewkesbury

The first reference to the Berkeley Arms is in 1869 but it is likely that the pub was trading as the Queens Arms before then. Given its antiquity, it is hardly surprising that there are a number of ghostly stories about the pub. For generations, mysterious heavy footsteps have been heard coming from the large front upper room, and in more recent times popular ex-landlady Ruby Jones, who passed away in 1993, is said to haunt the Berkeley Arms. Glasses have inexplicably fallen off shelves when Ruby is brought up in conversation.

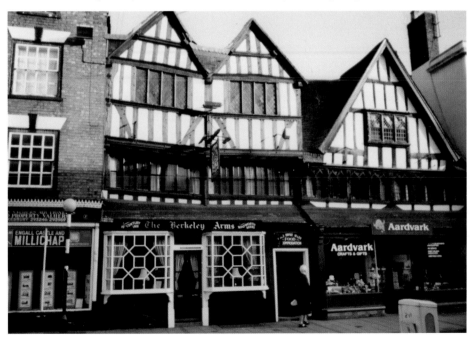

George Inn, High Street, Tewkesbury
The George is located on the western side of the High Street at the northern end by the junction of Red Lane. The George was once tied to the Tewkesbury Brewery Company, and in 1917 was purchased by Ind Coope & Co. of Burton-on-Trent. The archive photograph shows Ind Coope & Allsopp signage. In 1987, the pub had a brief change of identity to Brothers, aimed at the younger drinking set. After several attempts to revitalise the fortunes of the pub, it closed in 2007 and began trading as the George Bar & Restaurant. It is currently vacant.

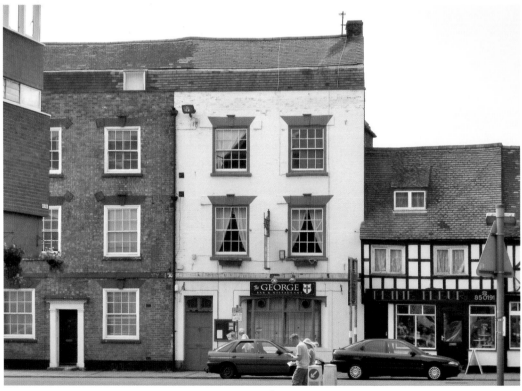

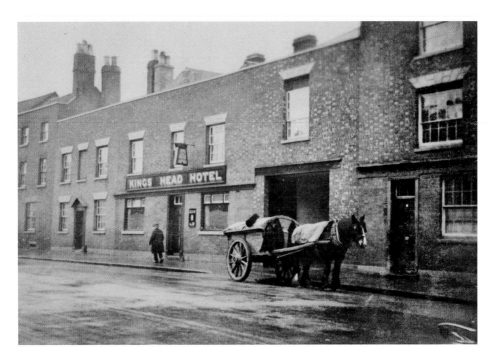

Kings Head, Barton Street, Tewkesbury

The Kings Head was once tied to the local Tewkesbury Brewery, which was acquired by Arnold, Perrett & Co. Ltd of Wickwar in 1896. Cheltenham Original Brewery gained ownership of the Kings Head in 1924. In 1999 the pub had a change of identity to the King Charles but it had closed by July 2001, reopening briefly only to close once again in 2003. A proposal to convert the Kings Head into a restaurant never materialised. The final pints of beer were pulled in the Kings Head in April 2006 following the sale of the pub to a property developer. The building is now residential.

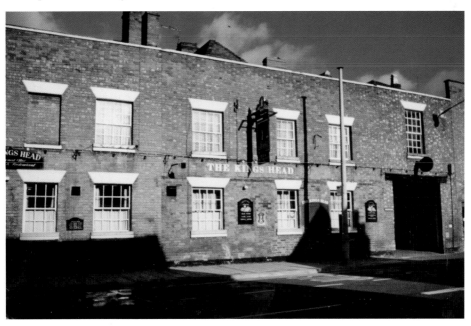

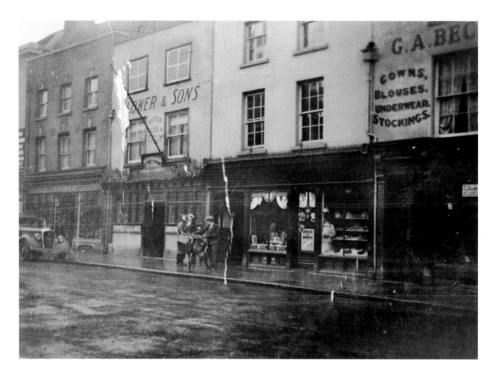

Nottingham Arms, High Street, Tewkesbury

The Nottingham Arms is the only pub to survive on the eastern side of the High Street. It was first licensed in 1869, and was one of the few local pubs tied to Bayliss & Merrell, who had a small brewery adjoining the Black Bear by St John's Bridge. The frontage of the Nottingham Arms is a twentieth-century reproduction, although the fabric of the building is sixteenth-century or older. The front had to be remodelled because of structural decay. It remains something of a mystery why the pub is called the Nottingham Arms.

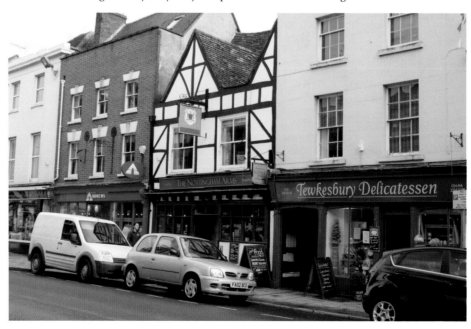

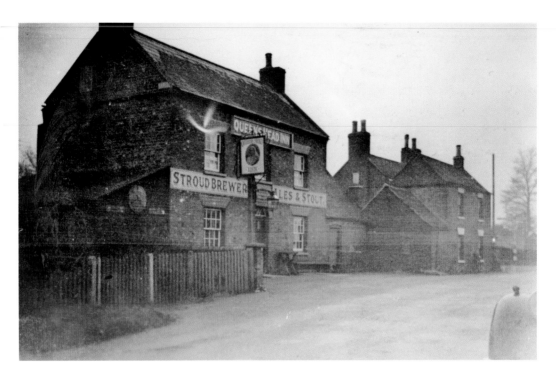

Queens Head, Aston Cross

At the time of preparing this book, the Queens Head had closed and was facing an uncertain future. Located 2 miles east of Tewkesbury town centre, on the junction with the A46 Stow road and the B4079 Bredon road, the Queens Head had been serving travellers for generations. Godsell & Sons of Salmon Springs near Stroud were the owners in 1903. The Queens Head was the most northerly pub in their estate, a considerable journey for the dray horses before the introduction of motorised vehicles. Stroud Brewery acquired the Queens Head in 1928.

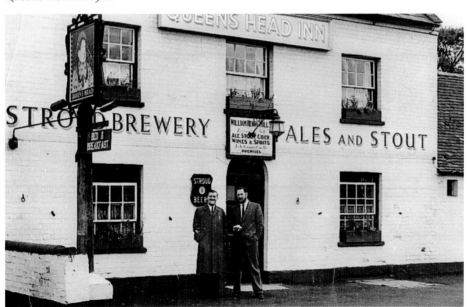

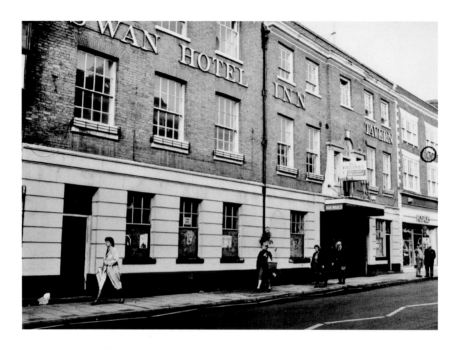

Swan Hotel, High Street, Tewkesbury
There is a reference to the Swan Inn in Tewkesbury in the thirteenth century, although not necessarily in the same High Street premises. In 1579, a virulent disease caused the death of five local residents, the first and last recorded case of the pestilence being at the Swan. At its heyday the Swan was the most prestigious coaching inn in town, but had fallen from grace in the 1970s when the entire upper floor was condemned as being unsafe. The Swan Hotel finally closed in the late 1980s.

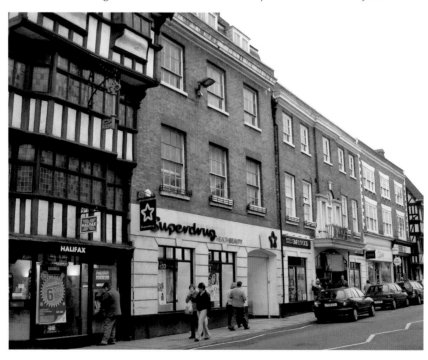

Wheatsheaf Inn, High Street, Tewkesbury

The Wheatsheaf at No. 132 High Street is a Grade II* listed architectural gem and retains many original features, including a fine panelled room, cobbled floors and superb cornice mouldings. Now Cornell's bookshop, there can be no better place to browse through books while soaking up the history of the early sixteenth-century building. Although the Wheatsheaf ceased trading as a pub in 1956, the license was apparently never revoked.

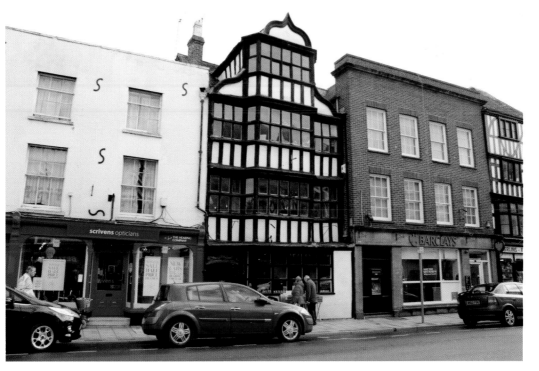

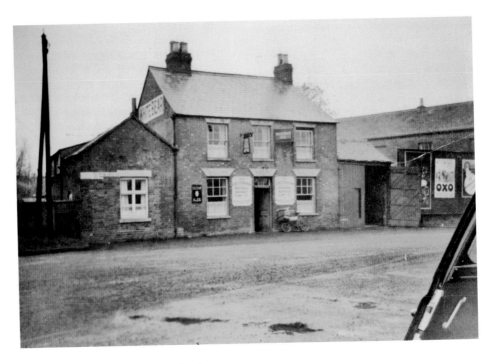

White Bear, Bredon Road, Tewkesbury

The White Bear is located just off the High Street to the north of the town, and the River Avon flows in close proximity. The pub was badly affected by the catastrophic floods in July 2007. At its height, the floodwater reached almost to the top of the ground-floor windows. After considerable refurbishment, the White Bear was inundated with floodwater again during Christmas 2012. Despite the setbacks, the pub continues to thrive.

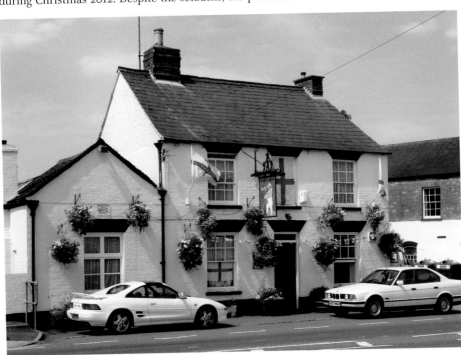

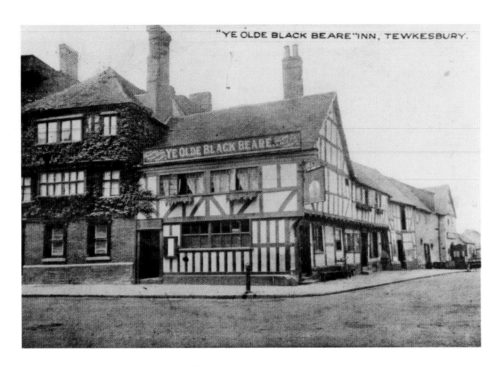

"YE OLDE BLACK BEARE" INN, TEWKESBURY.

Ye Olde Black Bear, High Street, Tewkesbury

Ye Olde Black Bear is at the northern end of the town, on the corner of the High Street and Mythe Road. The pub has a garden backing onto St John's Bridge on the River Avon. It was on this land that the distilling and brewing business of Bayliss & Merrell was once located. The Black Bear was reputedly built in 1308; it is therefore a strong contender for the title of Gloucestershire's oldest inn, although the bulk of the timber framing dates from the sixteenth century and there have been extensive alterations to the interior.

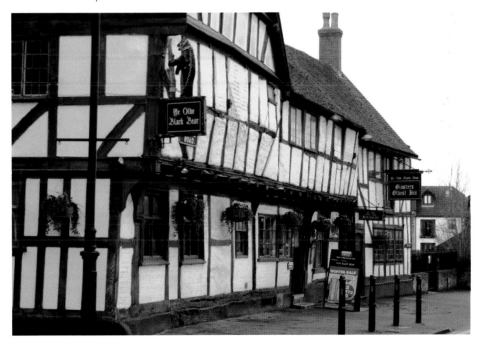

Lower Lode Inn, Forthampton

The fifteenth-century Lower Lode Inn is a brick-built inn on the eastern banks of the River Severn. The pub is only around 1 mile to the west of Tewkesbury but involves a 5-mile journey to get there by road. The Severn was once fordable at this point and it is said that the river was crossed by troops fleeing the Battle of Tewkesbury in 1471. A public ferry linking Lower Lode and Upper Lode was withdrawn in March 2000 when the Environment Agency decreed the mooring pontoon at the pub was unsafe and constituted a flood risk.

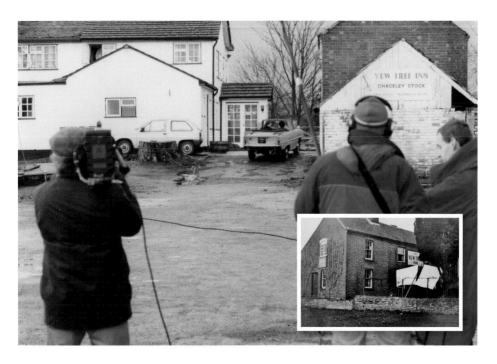

Yew Tree Inn, Chaceley Stock

The Yew Tree Inn is prone to flooding. During Christmas 1993 the pub was cut off by floodwater. The BBC sent a film crew to record their *Good Morning* show live from the Yew Tree. Presenter Bill Hanrahan was 'ferried' to the pub in Ivor Newby's 'Amphicar', a 1960s German built car with two propeller's powered by a Triumph Herald engine. They were made from steel and were prone to rust but are now fetching up to £50,000.

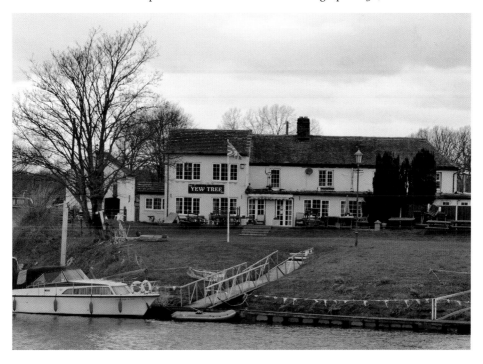

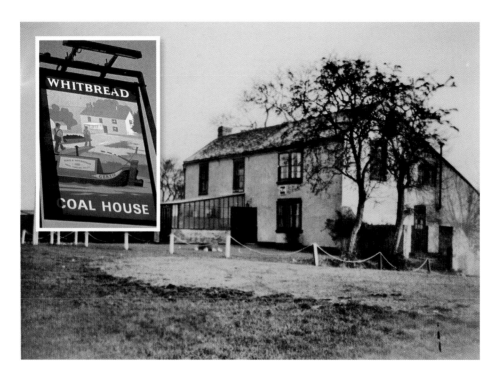

Coal House, Gabb Lane, Apperley

There has been a pub on the site since at least 1750 and it was previously known as the White Lion. In Victorian times, the pub was the unloading point for cargoes of coal from the Midlands bound for Cheltenham. Wharf wagons laden with coal were taken up the narrow lane into the village. During the Great Gloucestershire Flood of July 2007, the pub was 6 feet deep in floodwater. Fortunately, the Coal House continues to trade.

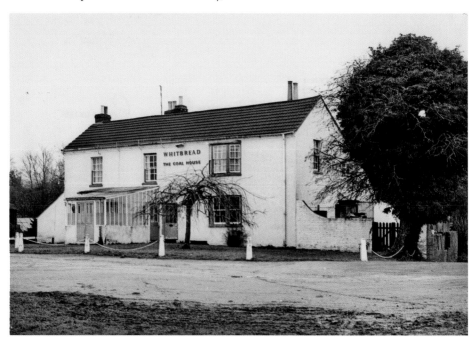

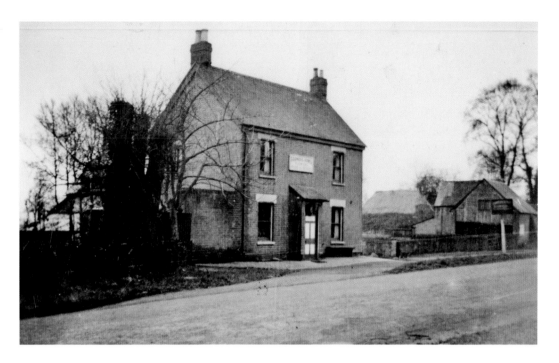

Farmers Arms, Lower Apperley

The Farmers Arms dates back to the sixteenth century. A small thatched farm building in the grounds of the pub was renovated in early 1992 and converted into a brewhouse. The first trial brews were made in May 1993 and the Mayhem's Brewery was officially launched in August 1993. The Farmers Arms was purchased by Wadworth of Devizes in 1996 and brewing ceased at Mayhem's Brewhouse in February 2001. Elvers, baby eels once caught in abundance in the River Severn, were reintroduced to the menu at the Farmers Arms in 2005. They were imported from Spain and sold at the pub at £14 for a 200-gram portion!

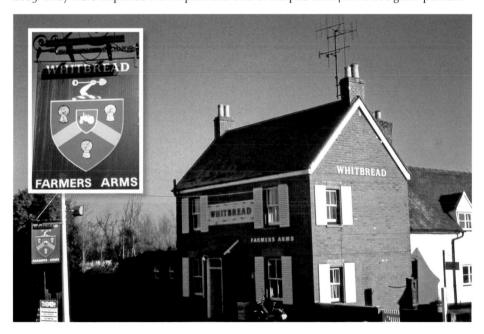

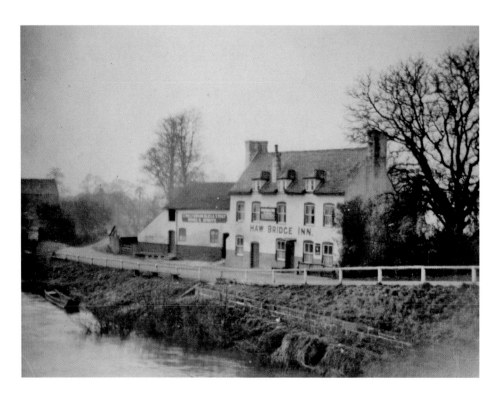

Haw Bridge Inn, Tirley

The Haw Bridge Inn is another riverside pub that is prone to flooding; 5 feet of floodwater wrecked the pub during the Great Gloucestershire Flood of July 2007. At the time, landlady Kelly Wright was heavily pregnant. She was taken to safety through the rising floodwaters in an amphibious vehicle, and gave birth to her son Mason on 29 July. Kelly married fiancé and fellow landlord Ian Balkie in September 2010.

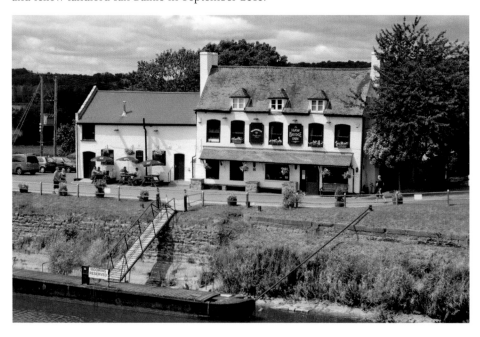

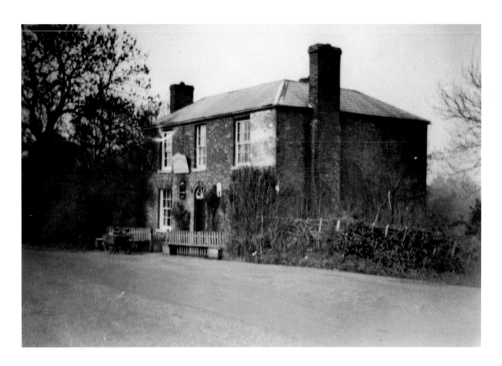

New Inn, Haw Bridge, Tirley

Old school pals of the Naunton Park School in Cheltenham had a reunion at the New Inn in February 2000. It was organised by landlord Peter Wise, a former pupil. Eddie 'the Eagle' Edwards, the Olympic ski jumper, was one of the ex-Naunton Park pupils at the reunion. A refurbishment in the summer of 2007 was badly timed, as just four days later on 20 July the New Inn was deluged with floodwater. The pub finally reopened in October 2008 under new ownership as the Riverside Inn. In 2012 trading tended to be sporadic, opening confined to the summer season.

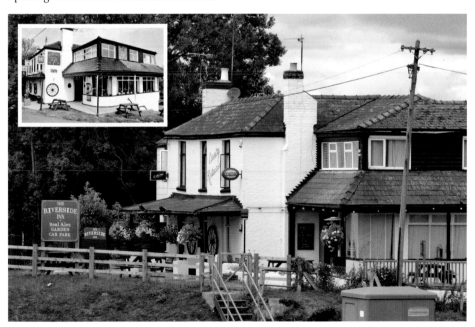

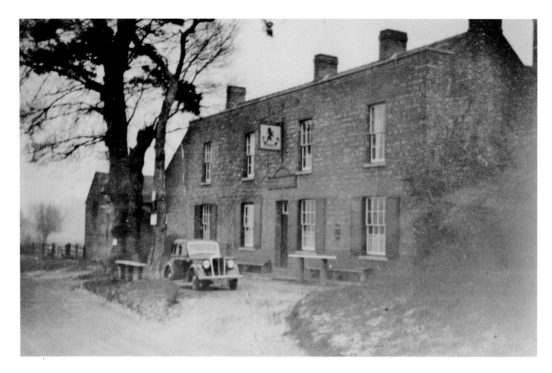

Red Lion, Wainlode Hill

In 1940, Joan Mitchell, aged only twenty, began a long tenancy at the Red Lion with her newly-wed husband Griff. When Mr Mitchell died of lead poisoning in 1950, Joan carried on at the pub. In 1963, Joan Mitchell bought three donkeys – Pip, Squeak and Wilfred – to give children rides on the nearby beach. Joan's son John took over the running of the pub in 1985 but his mother kept pulling pints at the Red Lion until John sold the lease in July 2001. Joan died in 2002.

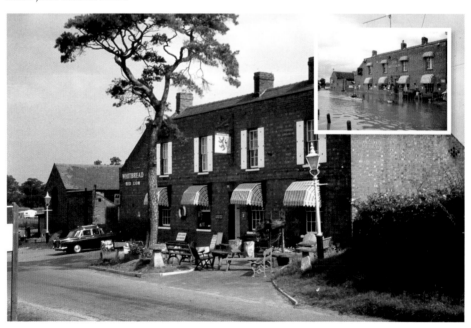

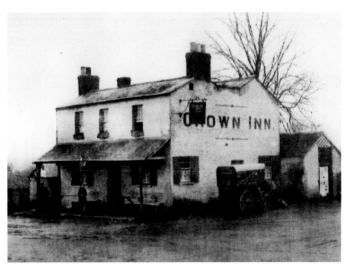

Crown Inn, Coombe Hill

It seems likely that the Crown was first licensed to serve the needs of bargees and carriers on the ill-fated 5-mile Coombe Hill Canal, which opened in 1796. Goods were transferred from barges to carts and taken up the hill and onwards towards Cheltenham, sustenance being taken at the Crown and Swan. However, only thirteen years later, the opening of the tramway from Gloucester to Cheltenham made the Coombe Hill Canal hopelessly uneconomic. In 1876 the canal was abandoned. The Crown Inn closed soon after the First World War.

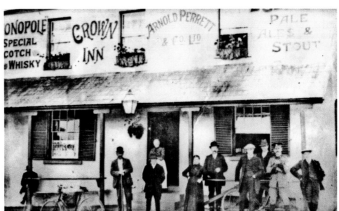

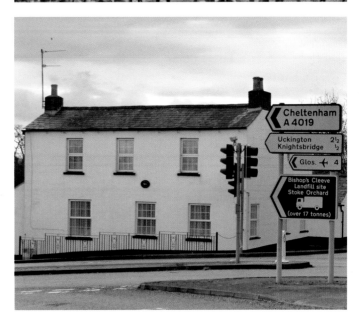

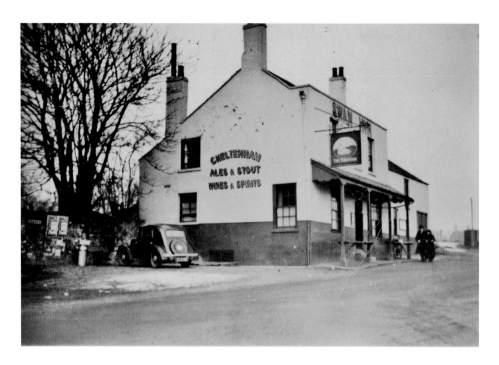

Swan Inn, Coombe Hill

This ex-Whitbread pub was refurbished in September 1996 by the Little Pub Company and reopened as Rene Descartes Vineyard. The bar ceiling was lined with thousands of wine bottles and the French theme dominated the pub – complete with French mechanical monkeys. The theme came to an end in 2000 when the pub reverted to its original identity. A vineyard planted at the side of the pub continues to yield two varieties of grapes each autumn: orion (white) and rondo (red).

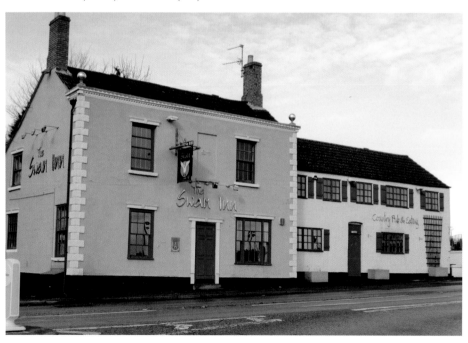

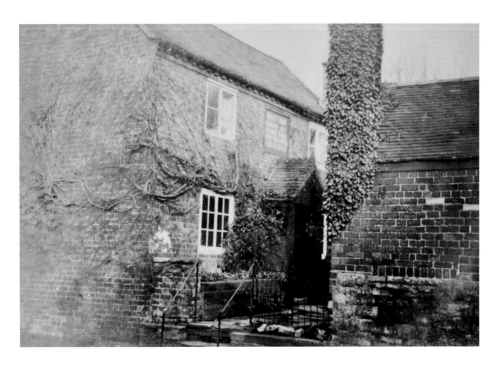

Boat Inn, The Quay, Ashleworth

The eighteenth-century Boat Inn, on the west bank of the River Severn, is undoubtedly one of the best pubs in Gloucestershire. The Jelf family had a long association with the Boat Inn – running it for an amazing 350 years. The traditional pub is now run by Ian Lock, who takes great pride in his real ales. Ian has installed a 22-gallon microbrewery in the old stables opposite the pub, and a larger six barrel brewery at Deerhurst (Wicked Brew) supplies the Boat and other outlets. History is repeating itself, as David Jelf brewed beer at the Boat Inn over a hundred years ago.

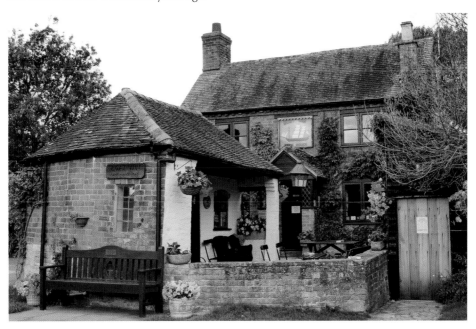

Queens Arms, Ashleworth

The Queens Arms was built around 1835. It was once tied to the Tewkesbury Brewery Company and later owned by the Wickwar Brewery trading as Arnold Perrett & Co. In the winter of 1981/82 the pub was renamed the Arkle, after the three-time consecutive Cheltenham Gold Cup winner in 1964–66. At that time the pub sold beer from the Donnington Brewery, which was owned and run by Claude Arkell. It reverted back to its original name in the early 1990s and is now primarily a pub-restaurant.

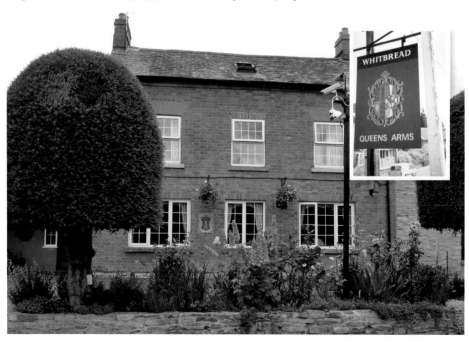

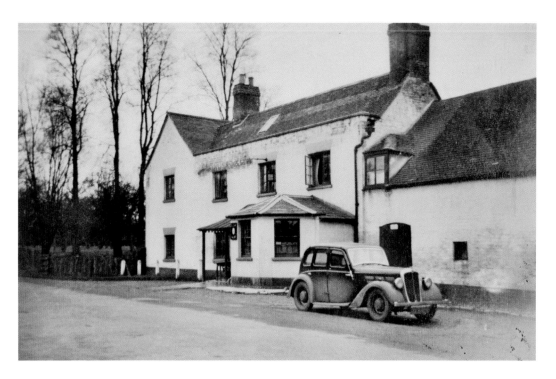

Canning Arms, Hartpury

In the mortgage taken out on the Hartpury estate in 1908, the tenants of the Canning Arms were the Royal Well Brewery Co. Ltd. of West Malvern, probably the only Gloucestershire pub that sold beers from the Royal Well Brewery. The Canning Arms was delicensed in 2002, and in 2007 a planning application was submitted to Forest of Dean District Council to create two separate dwellings at the property.

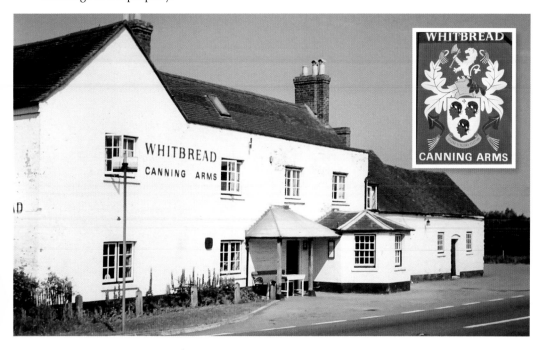

Rising Sun, Hiams Lane, Hartpury

The Rising Sun is tucked away up a quiet country lane, around a mile to the south of Hartpury. It is actually located within the parish of Maisemore. The pub is also known as the 'Salt Box', a reference to a time when a building on the site was used to store salt being transported to Gloucester. At the time of writing, the Rising Sun was on the market as a going concern yet also offered for residential or commercial use subject to planning consent.

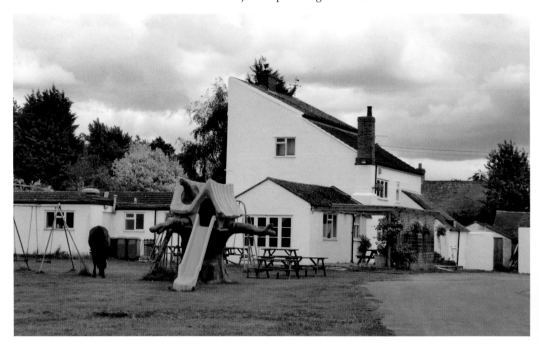

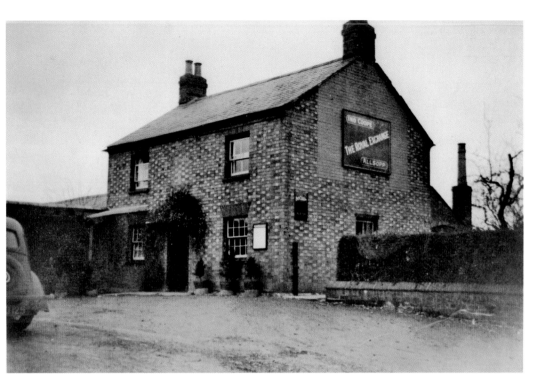

Royal Exchange, Hartpury

The Royal Exchange takes its name from local Civil War associations. It was on the site of the pub where prisoners from the Royalist and Roundhead sides were exchanged. It was once a tied house of A. V. Hatton's Northgate Brewery, Gloucester, who were subsequently acquired by Ind Coope & Co. of Burton-on-Trent. The Royal Exchange has recently been refurbished and offers good food and well-kept ales.

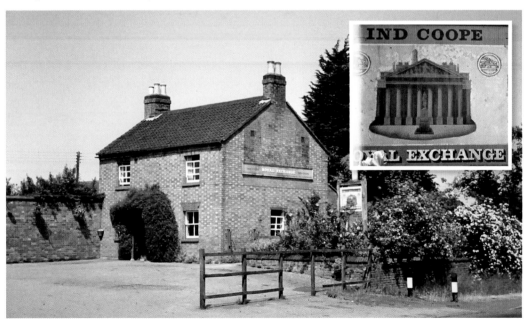

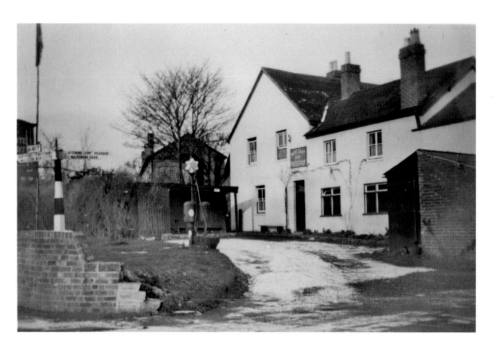

White Hart, Ledbury Road, Maisemore

On a dark and foggy night on Tuesday 11 February 1896, Thomas Cox, the lock-keeper at Maisemore Lock, called into the nearby White Hart and drank a few pints of Arnold Perrett's Wickwar Ales. He left the pub at around 9.30 p.m., and accidently walked over the lock wall and drowned. The inquest was held at the White Hart and concluded that Thomas had left without his lamp and, clutching a bottle and jar in each hand, had lost his balance and tumbled into the icy waters.

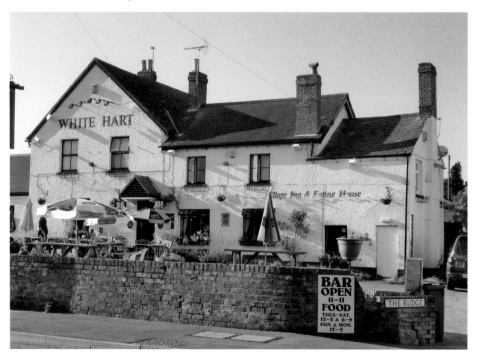

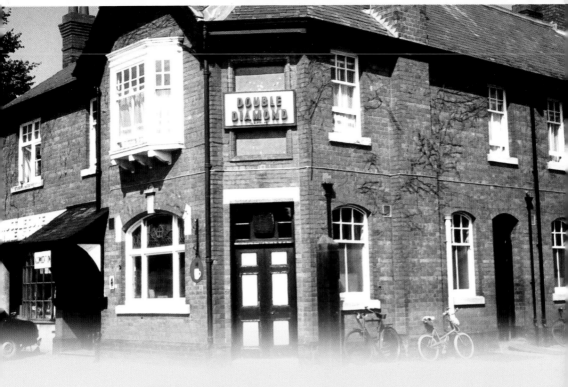

CHAPTER 2

In & Around Gloucester

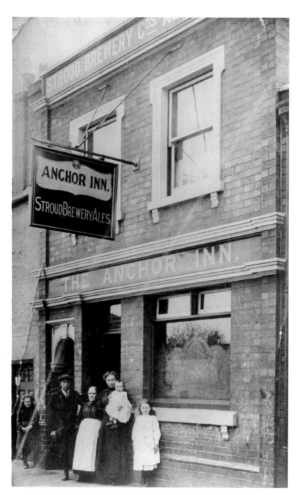

Anchor Inn, Sweetbriar Street
The Anchor, owned by the Stroud Brewery Company, was a simple brick-built building in a row of terraced houses. The pub had successful darts and crib teams. The Anchor Inn was demolished around 1957, when it was sold to the County Borough of Gloucester for £1,350. The site of the Anchor is now occupied by the playing fields of the Kingsholm Church of England Primary School.

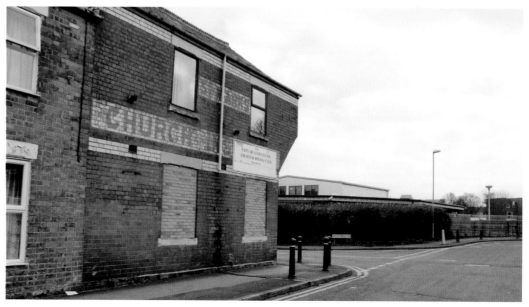

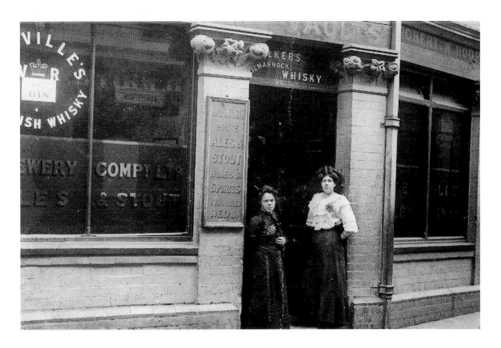

Barley Mow, Hare Lane

Robert William Hooper is listed as the landlord of the Barley Mow in Hare Lane in the 1906 Kellys Directory. His name can be seen above the right-hand window in the archive photograph, although the word 'Vaults' above the main door casts some doubt if this is actually the Barley Mow. I am happy to be corrected but could not resist including the image of this Nailsworth Brewery pub. The last recorded reference to the Barley Mow in Hare Lane is in 1919. There was another Barley Mow in Southgate Street, which was still open in the mid-1970s.

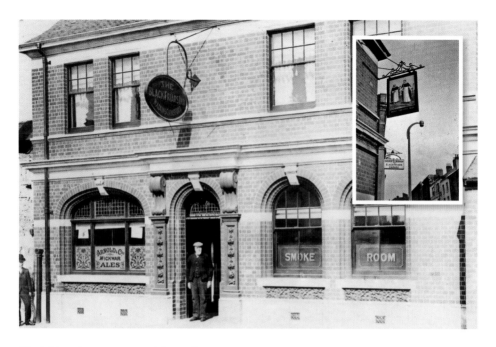

Blackfriars Inn, Commercial Road

The Blackfriars Inn was named after the medieval monastic building that is immediately behind the pub – the venue of the inaugural CAMRA Gloucester Beer Festival held in March 2013. The pub closed in the late 1970s. The locals participated in the Gloucester shove ha'penny league, which had nine divisions in the 1970s. The ancient pub game is now almost extinct – a victim of changing lifestyles. After closure, the Blackfriars Inn remained empty for a long period. In January 2012, the University of Gloucestershire applied for planning permission to turn the former pub to a business incubation centre.

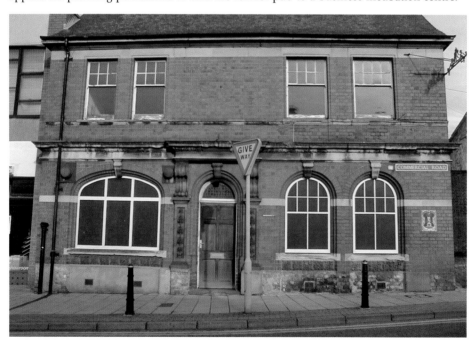

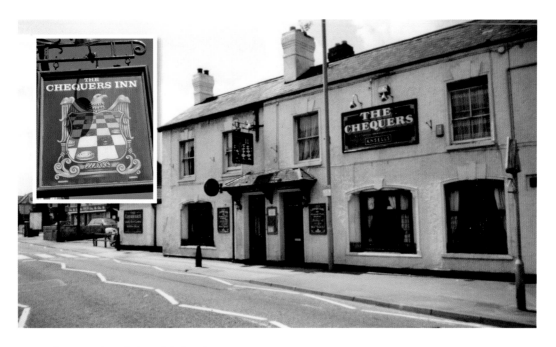

Chequers Inn, Painswick Road

The Chequers Inn had a bar, lounge, double skittle alley and extensive gardens. The regulars at the pub raised considerable amounts of money for charitable causes, and in 2005 the Gloucester Folk Club met at the Chequers on the second Thursday of every month. By 2008, however, the pub had closed and it was demolished in January 2010. Salaam Close, a housing development, now occupies the site.

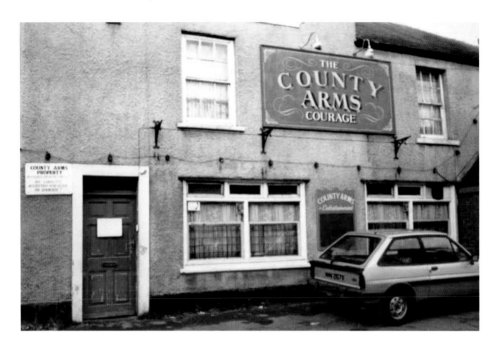

The County Arms, Millbrook Street

Although the County Arms closed over fifteen years ago, it is certainly not forgotten. Indeed, the simple cider pub, run by Cocker Jones and his mum (known to regulars as 'mother'), was frequented by both the wealthy and the less well-off, and is celebrated to this day by the County Arms Luncheon Club (founded 1972) who meet annually for 'nostalgia, bonhomie and camaraderie' ... and cider. Local wit Martin Kirby once remarked that 'in the County Arms, every day was Red Nose Day'. The pub was demolished in 1998.

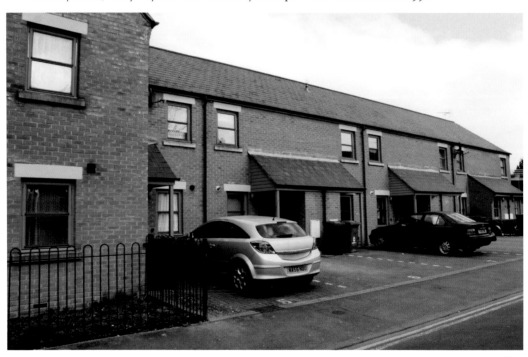

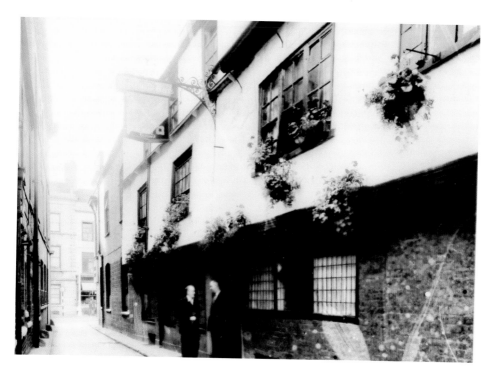

Cross Keys, Cross Keys Lane

Tucked away in a side street, just off Southgate Street, the sixteenth-century Cross Keys Inn is known to have been a tied house of the City Brewery in 1894. It was a popular Stroud Brewery pub in the 1950s. More recently, the old bar and lounge areas were knocked through to create a larger drinking space. Ironically, the interior of the Cross Keys was subdivided once again in 2012 to create an antiques centre and a smaller bar. Despite the alterations, the Cross Keys retains some original features.

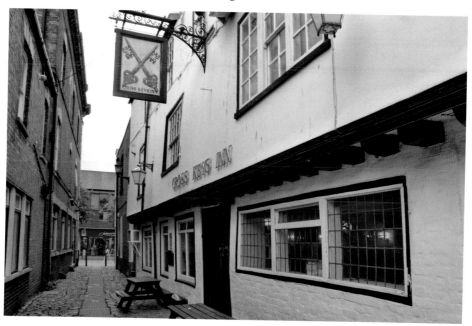

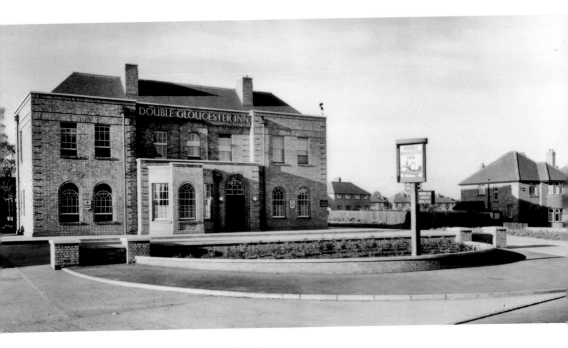

Double Gloucester, Cheltenham Road, Longlevens

The Double Gloucester, on the old main road from Gloucester to Cheltenham, was opened on 15 December 1937 by the Stroud Brewery Company. The pub was built on the site of a grand, red-brick Victorian house called Colebridge House. It was named the Double Gloucester to perpetuate the name of one of the most famous products in the county – Double Gloucester Cheese. Given the trend of renaming pubs in recent years, it is a wonder that it is not called the Stinking Bishop! Perhaps that would be too cheesy.

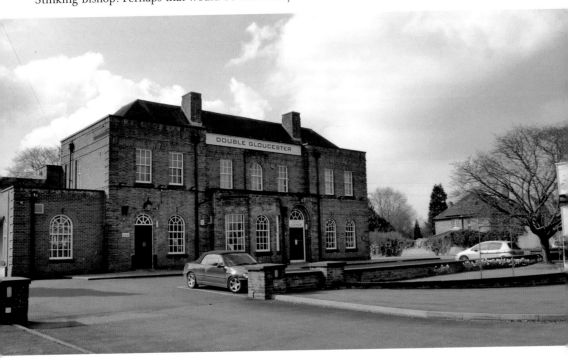

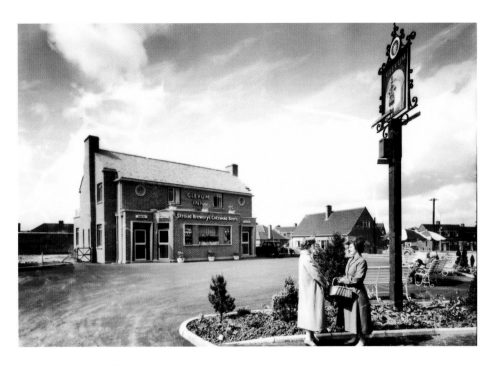

Glevum Inn, Oxtalls Way

The Stroud Brewery took photographs of their pubs for their in-house magazine *The Stroud Brewery Courier*. Peckhams of Stroud were usually contracted to take the photographs and went to great lengths to get the best images, often including people in the composition. When the Glevum Inn was opened in the late 1950s, Peckhams included two ladies in the photograph. Their conversation is unknown; perhaps they were debating the qualities of Stroud Brewery beer.

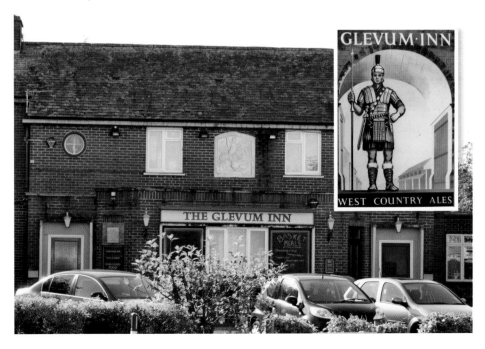

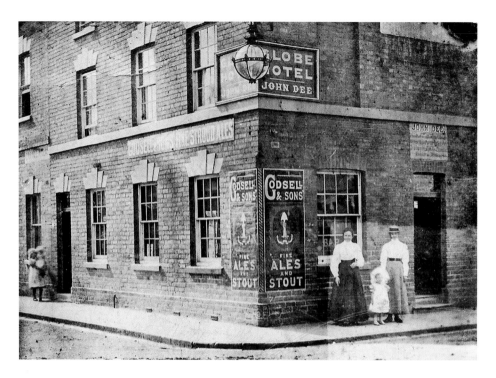

Globe Hotel, Quay Street

In the early 1970s, the County Militia Barracks in Quay Street were demolished to make way for a new block of offices for Shire Hall, and where the Globe Hotel once stood is now a staff car park. The Edwardian beer drinker could have had a great pub crawl around Quay Street. Apart from Godsell's at the Globe, Nailsworth Brewery beers could have been sampled at the Duke of Gloucester, Smith's Brimscombe ales at the Elephant and Castle, Wintle's Mitcheldean beers at the Mermaid, and Cheltenham ales at the Star Inn.

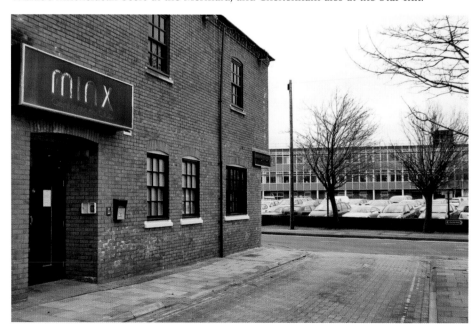

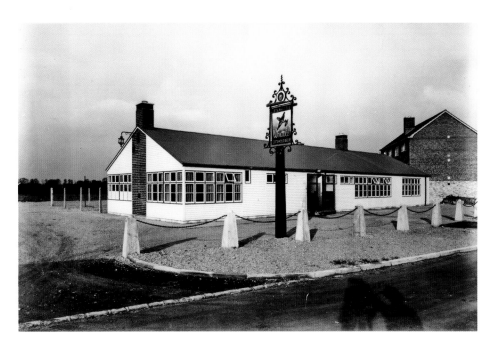

Jet & Whittle, Shakespeare Avenue, Lower Tuffley
In 1953, the Stroud Brewery Company were keen to build a new pub for the residents of Podsmead, a rapidly growing housing estate to the south of Gloucester. At the time, however, there were stringent building regulations and it was not possible to construct a traditional brick building. To overcome this problem, the Stroud Brewery set up their own building department and the Jet & Whittle was built by the brewery's own men. It opened on 9 November 1953. The 'prefab pub' was eventually replaced by a substantial brick building and, following closure and a long period of dereliction, was finally demolished in 2013.

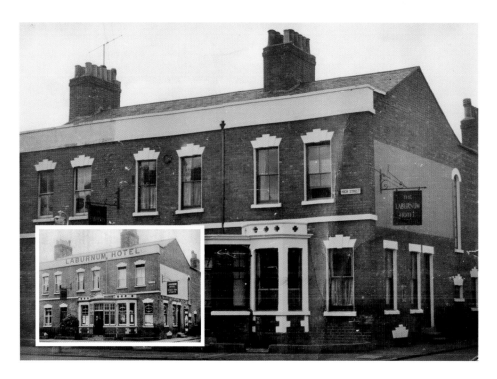

Laburnham Hotel, High Street

The Laburnham Hotel was situated on the corner of Tredworth High Street and Ryecroft Street. The building is now in use as the Ryecroft Bail Hostel. An 1894 advert from County Adverts states, 'John Apperley & Co – Brewers and wine & Spirit Merchants. Laburnham Brewery, Gloucester. Home Brewed Mild and Bitter Ales and Invalid Stout. Established 1842.' The home-brewed ales were also available at the Beehive Inn, Millbrook Street. It seems that the brewing business and the Laburnham Hotel were acquired by Godsell & Sons of Stroud.

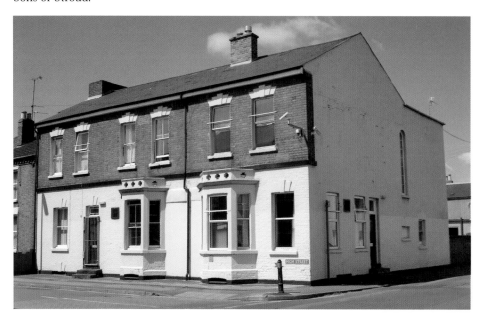

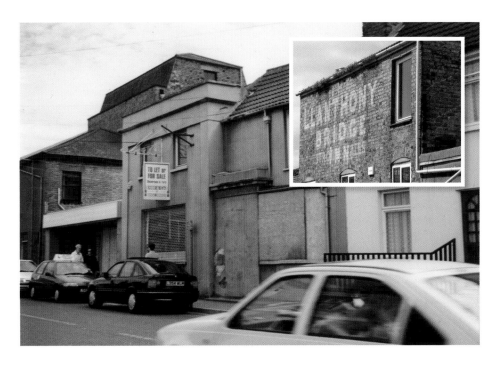

Llanthony Bridge Inn, Llanthony Road

Last orders were called for the final time at the Llanthony Bridge Inn around 1974. Just after closure, a team of archaeologists used the building as a base and slept overnight at the old inn. They were all disturbed by loud crashing noises and the unexplained slamming of doors. The building was subsequently converted into a tool hire shop and was demolished in 2008 to make way for the prestigious Gloucester Quays development. Against all odds, the Goat Inn, another long closed pub in Llanthony Road, survives.

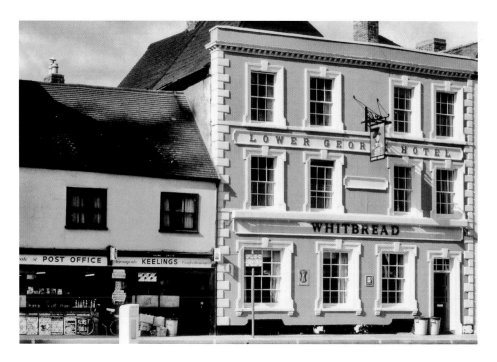

Lower George Hotel, Westgate Street

In 1873 the Lower George Hotel brewed 'Home Brewed Ales of excellent quality'. One hundred years later, it was an ordinary Whitbread pub selling the likes of Trophy and Tankard. The Grade II listed Lower George was sold to the Wolverhampton & Dudley Breweries in 1991 (Banks's) and then, in 1997, to the Little Pub Company, who painted the exterior in a garish orange and green and renamed it Mad O'Roukes. More recently it was trading as the Pig Inn the City, a popular real ale pub, until its sudden closure in 2012. The pub is currently empty with an uncertain future.

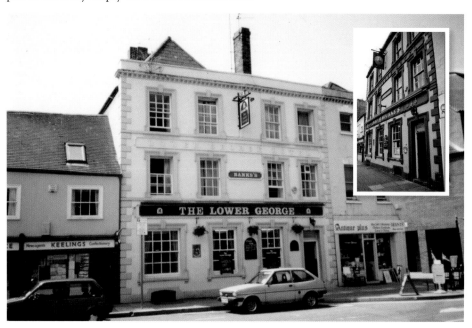

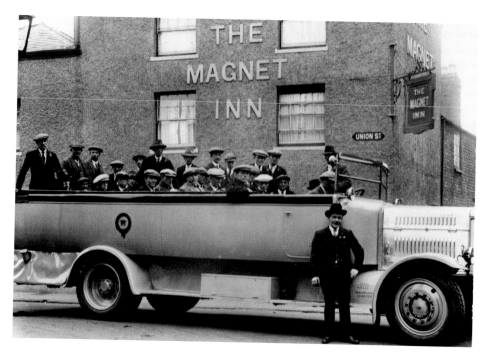

Magnet Inn, Union Street

The Magnet Inn was situated on the north-west corner of the junction of Union Street and Suffolk Street in the Clapham area of Gloucester. The whole area was demolished in 1961 and replaced with new council housing. The photograph of the charabanc was taken before the Second World War but the exact date isn't known. The gentleman standing in front of the vehicle is landlord Frederick Boon. He tragically died in a motorcycle accident on the Stroud to Cheltenham road. The driver of the charabanc was Percy Hough of Hough & Witmore garage, Gloucester.

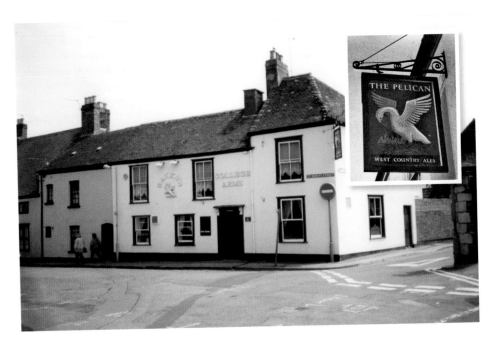

Pelican Inn, St Mary Street

An 1873 advertisement describes, '"Belchers" Pelican Inn, Gloucester. Choice Wines, Excellent Spirits, Home Brewed Beer. Every accommodation for Commercial Gentlemen.' In 1991, Banks's Brewery of Wolverhampton acquired the pub from Whitbread, gave it a makeover and renamed it the College Arms. Avebury Taverns then took ownership and in April 2007 it was trading as the Old Pelican and Bistro. The Pelican is now owned by the highly regarded Wye Valley Brewery and is one of the best and friendliest real ale pubs in Gloucester.

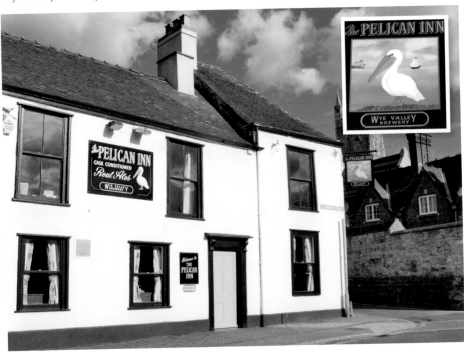

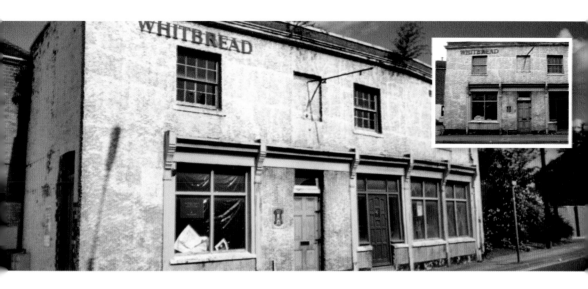

Red Lion, Barton Street

The address of the Red Lion was No. 229 Barton Street, just a few yards from Ye Olde India House. The 1978 edition of *Real Ale in Gloucestershire* (CAMRA) described it as a 'good pub with entertainment, skittle alley and function room'. I seem to recall that it had etched Stroud Brewery windows – can anyone confirm that? The Red Lion closed in 1984 and was left empty and allowed to deteriorate for the next twenty years before it was demolished.

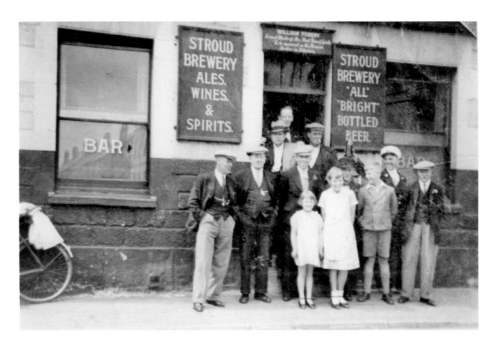

Star Inn, Victoria Street, Tredworth

The children in the photograph belong to the landlord William (Bill) Febery and are from left to right: Marion, June, Denis. It was taken in the 1930s. The Star had a successful ladies darts team in the late 1950s/early 1960s called the Meteors, who won the Ladies Darts League on several occasions. Betty Thomas, of the Meteors, went on to play in inter-town competitions as well as going through to the finals to several county and national competitions.

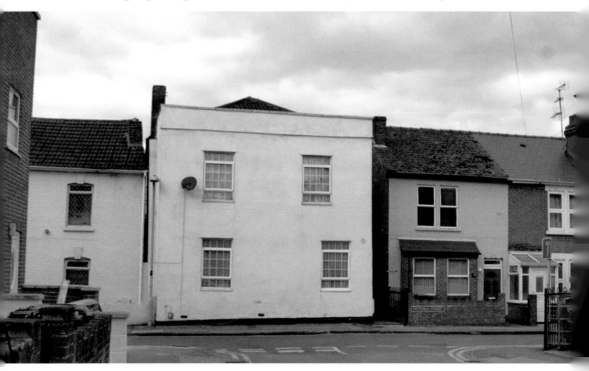

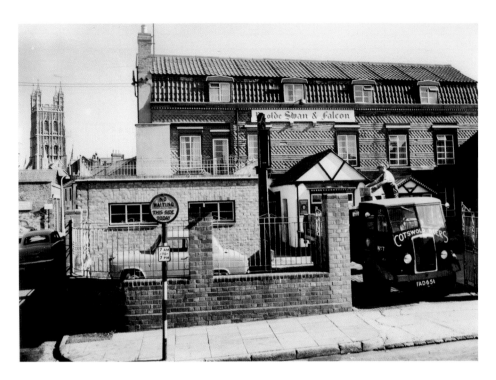

Swan & Falcon, Longsmith Street

In its heyday, in the 1960s, the Swan & Falcon was a popular venue for live music. On one occasion, when the Mystics played in the pub's skittle alley, the protective chipboard floor, which the band had placed over the surface to facilitate dancing, was a cause of much embarrassment when a woman's stiletto heels got embedded in the temporary surface. The Swan & Falcon also had a successful darts team; in May 1960 a new world record was gained when a score of 1,000,001 was achieved in 17 hours and 34 minutes.

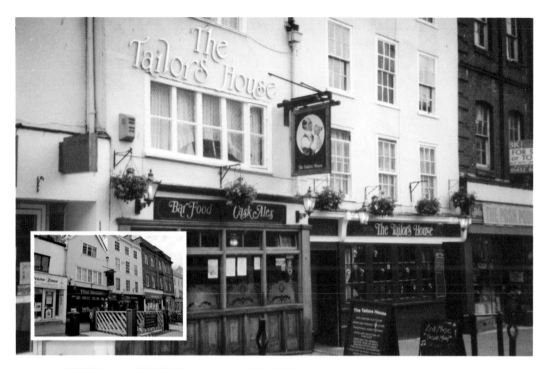

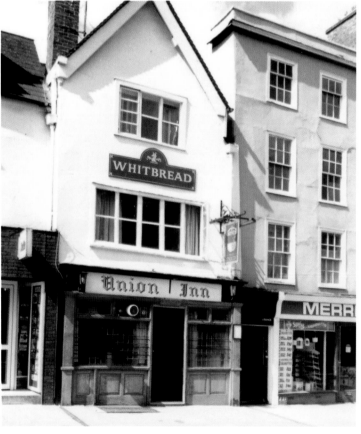

Union Inn, Westgate Street

Originally the Spirit Vaults, the name of the Westgate Street pub was changed to the Union to celebrate the 1800 Acts of Union with Ireland. In the late 1980s, it was renamed the Tailors House after Beatrix Potter's book *The Tailor of Gloucester*. The pub extended into the newsagent's shop to the right of the pub, which was once the workshop of Mr Pritchard, a tailor, who is said to have inspired the young Beatrix to write her story when visiting Gloucester. The name reverted back to the Union Inn in November 2003, among some strong controversy.

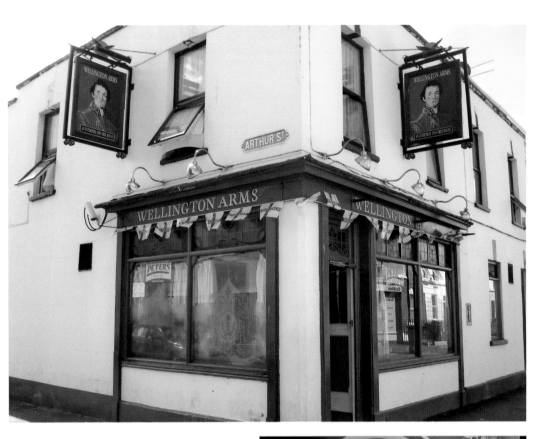

Wellington Arms, Wellington Street
The Wellington Arms closed in November 2008 and at the time of writing this book stood empty. The pub has some very rare, if not totally unique, Godsell & Sons etched brewery windows – remarkable survivors that date back to the 1920s. Protective metal shutters have been removed, leaving these fine windows exposed to possible vandalism.

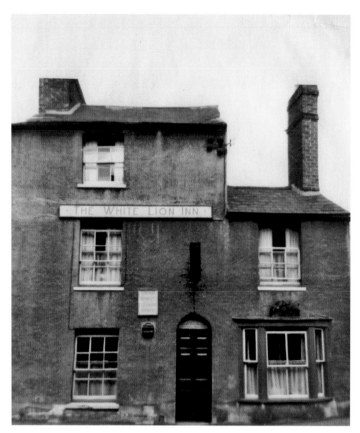

White Lion, Alvin Street
The White Lion was on the corner of Alvin Street and Sherborne Street. The address is given as No. 38 Alvin Street in the 1919 Kellys Directory. The White Lion was referred to the compensation authority on 3 February 1919 but survived the recommendation for closure. In the 1950s, the White Lion was tied to the Stroud Brewery Company. This area of Gloucester, known as Clapham, was transformed in the early 1960s, when the old back-to-back houses of the community were replaced with new council housing.

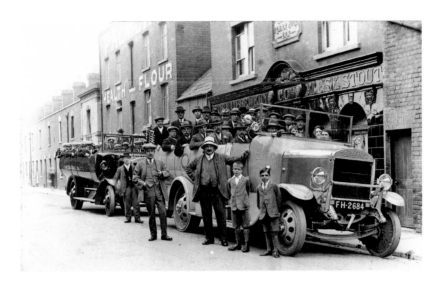

Ye Old Robin Hood, Hopewell Street

Without doubt, the Robin Hood Inn, just off Barton Street, has the most impressive pub frontage in Gloucestershire. Rebuilt by the Stroud Brewery Company in 1908, the Robin Hood Inn used to have etched Stroud Brewery windows as well. The interior of the pub was also fitted out with mahogany bar fittings and decorative tiles – a real gem. It closed under Whitbread ownership in November 1977. The tiled lettering was revealed in all its glory when the corporate Whitbread sign was removed.

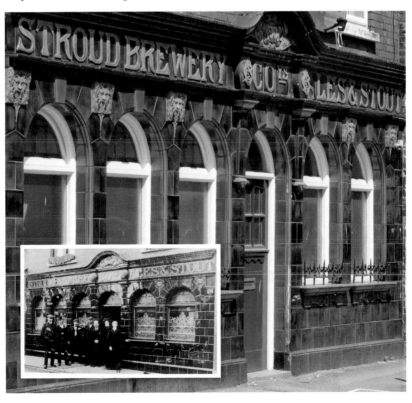

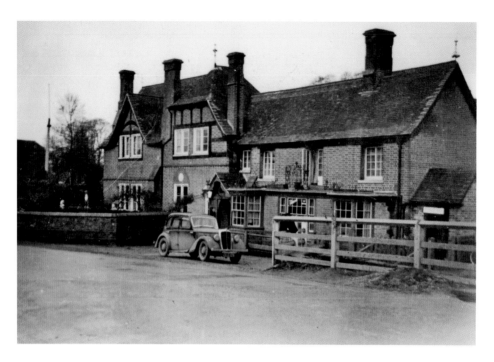

Dog Inn, Over

In August 1998, the owners, Toby Inns, announced that a major £435,000 refurbishment of the Dog Inn would also involve a change of name to Toby Carvery. The statue of the black Labrador dog, which stood outside the pub for nearly a century, was donated to the nearby Over Farm Market. Not content with changing the pub name, the owners also effectively moved the pub geographically from Over to Highnam. The Toby Carvery at Highnam opened on 16 November 1998.

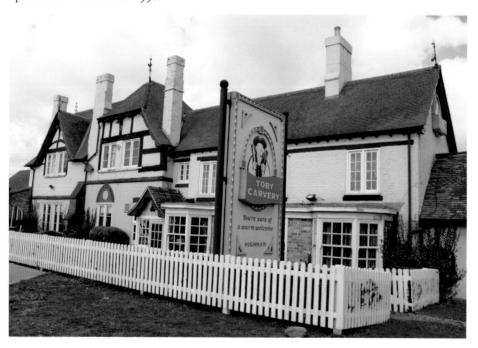

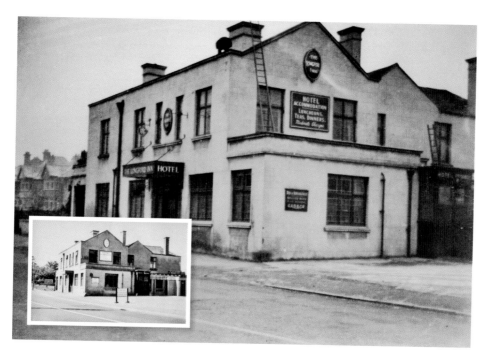

Longford Inn, Tewkesbury Road

On Monday 30 October 2000, the Longford Inn was used as a makeshift refuge for sixty villagers from nearby Sandhurst. A chemical factory exploded in the village, sending massive fireballs 'the size of houses' into the sky as drums of chemicals exploded at the CSG site. Two of the conference rooms at the pub were turned into bedrooms during the disaster, and bedding was borrowed from the neighbouring Travel Inn. The Beefeater pub laid on food and drink throughout the day, before locals were allowed to return to their homes.

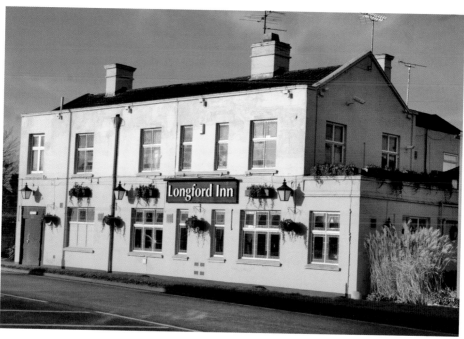

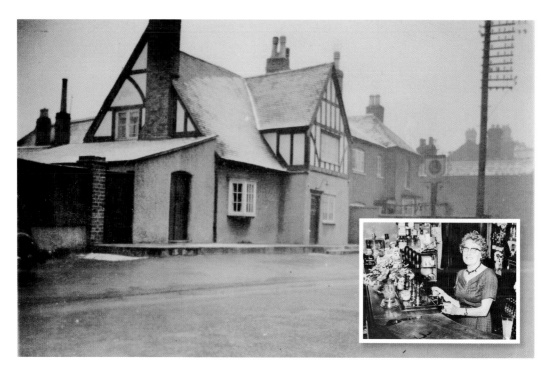

Queens Head, Tewkesbury Road, Longford

The Queens Head, on the A38 road north of Gloucester, dates back to the 1730s and was originally a blacksmith's, serving horsemen and carriages entering and leaving the city. Doris Alexander (pictured) took on the Stroud Brewery tenancy in the late 1930s with her husband Edward and, after his death, ran it herself for thirty years or so. In the 1970s she married William Moth and they ran the Queens Head together until the 1980s. Both William and Doris died in September 1987, just a few weeks apart.

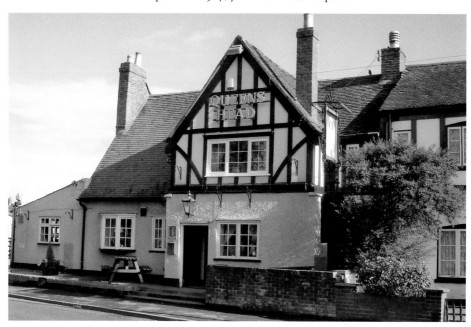

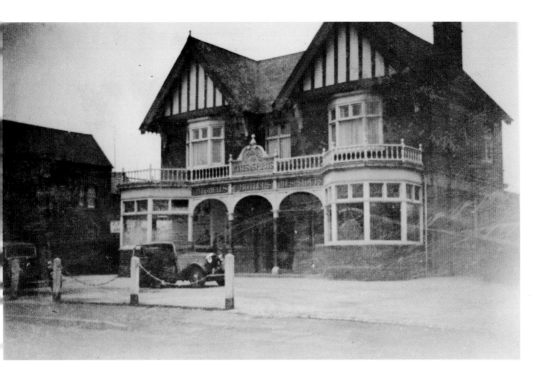

King Edward VII, Old Cheltenham Road, Longlevens

The King Edward VII is affectionately known as the 'King Teddy'. It was built in 1905 and was named after Edward VII's visit to Gloucester in 1904. The license was probably transferred from the Globe Inn, which was located on the other side of the Old Cheltenham Road. The Edwardian pub was enlarged and refurbished in both the 1970s and 1980s. The King Edward VII opened as an Ember Inns pub in December 2001 after a £500,000 refit.

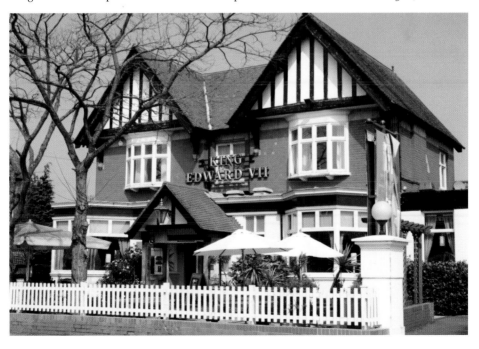

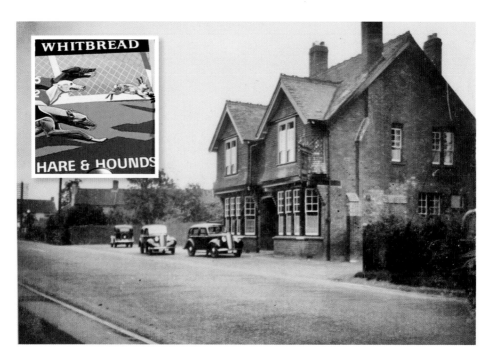

Hare & Hounds, Cheltenham Road East, Churchdown

The Hare & Hounds once sold beer from Arnold Perrett & Co.'s Wickwar Brewery. Alfred Thomas Rose Baldaro, landlord, was summonsed in 1898 for violently ejecting a customer, but the case was dismissed. He was, however, convicted and fined £1/12s/0d, including costs, on 11 November 1899 for permitting drunkenness on the premises. The ownership of the pub passed through the hands of the Cheltenham Original Brewery, Cheltenham & Hereford Breweries, West Country Breweries, and Whitbread. The Hare & Hounds became part of the Greene King pub group in July 2004.

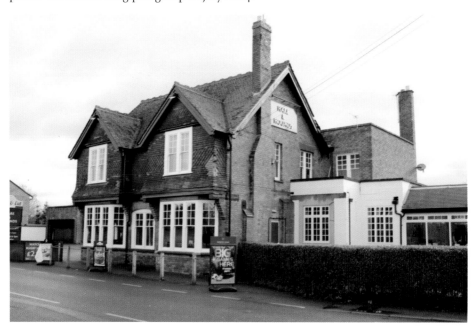

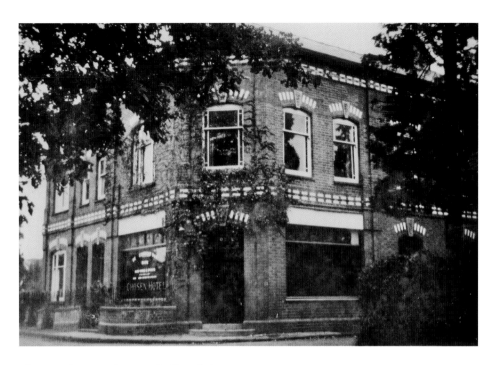

Chosen View, Station Road, Churchdown

The Chosen Hotel, on the junction of Station Road and Albermarle Road, was located near Churchdown railway station. It was originally built in 1897 as a temperance hotel, but had obtained a licence by 1903. It had a six-day licence as late as 1936. When the railway station succumbed to the Beeching cuts in November 1964, the fortunes of the Chosen Hotel slowly went into decline. The Chosen Hotel closed in the late 1980s and the Priory Court housing development now stands on the site.

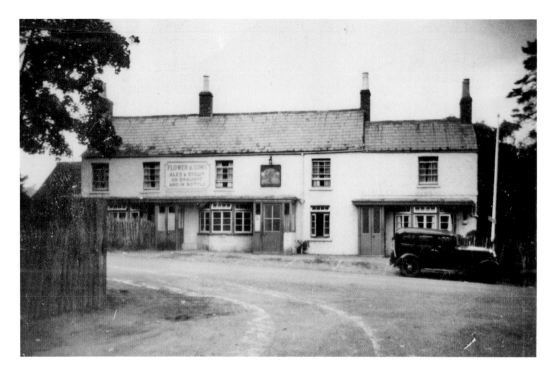

Bat & Ball, Church Road, Churchdown

When Gloucestershire County Council put forward plans in the 1930s for the construction of a new main road from Cheltenham to Gloucester, passing through Churchdown village, Flower & Sons of Stratford-upon-Avon, the owners of the local 'cottage style' pub called the Old Elm, took the decision to apply for a transfer of license to build a large pub on the proposed route of the new road. The traditional Old Elm Inn was demolished in 1938 to make way for the modern roadside pub. Then, in the ultimate of ironies, the proposed new main road from Cheltenham to Gloucester was cancelled.

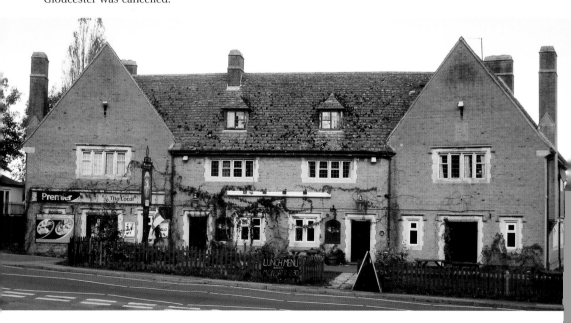

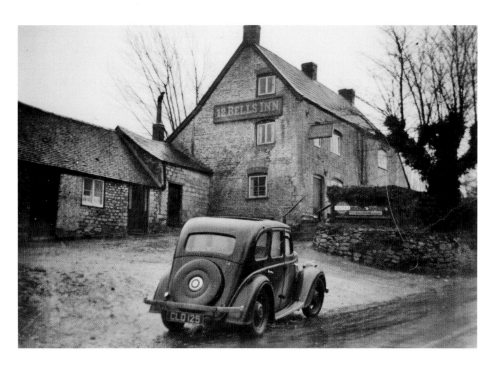

Twelve Bells, Witcombe

The origin of the pub name is a bit of a mystery. Witcombe church originally only had two bells; four more were added in 1901 in memory of the late Elizabeth Caroline Hicks Beach. Gloucester Cathedral, however, has twelve bells, but the city is 6 miles or so to the west. To confuse matters further the pub sign has a painting of Cirencester church! In the 1960s the Twelve Bells was enlarged and an adjoining farmworkers' cottage became part of the pub. In 1966 a T-bone steak with chips and mushrooms cost just 14s/6d.

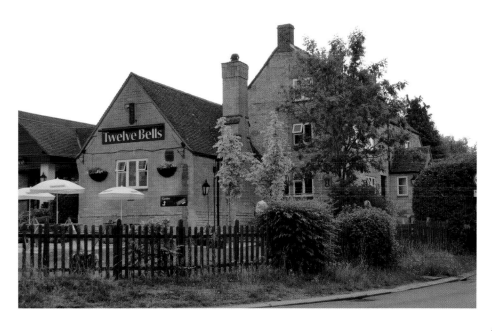

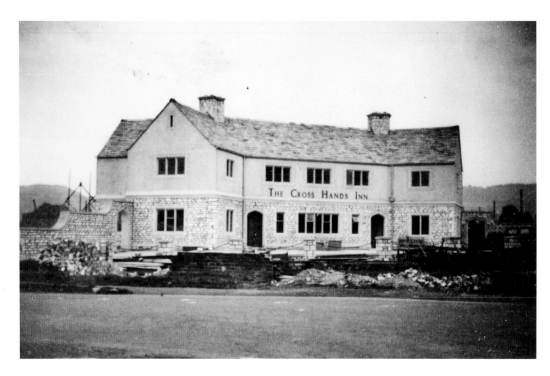

Cross Hands, Shurdington Road, Brockworth

The Cross Hands was built for the Stroud Brewery Company and opened on 13 December 1937. It replaced an older building of the same name, which was demolished for the construction of the roundabout. In the 1960s the skittle alley was the venue for the Dandelion Club disco, which also hosted the occasional live band – in 1968 Peter Green's Fleetwood Mac played there. In March 2002, the pub had a £400,000 revamp and reopened as Brewsters, later becoming a Brewers Fayre. The Toby Carvery at the Cross Hands opened on 18 December 2006.

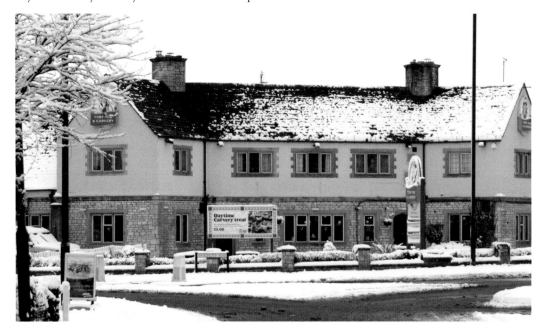

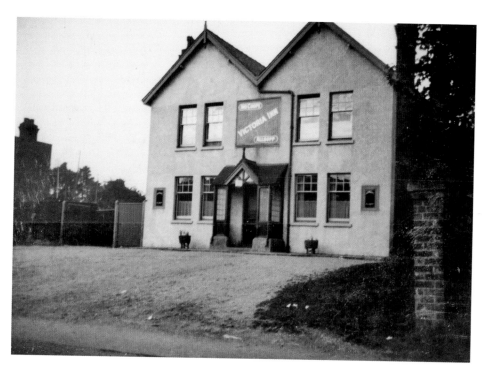

Victoria, Hucclecote Road, Brockworth

I was intrigued to find the owners of the Victoria Inn in 1891 were listed as Jaynes & Scholey. I thought this could be a small brewery, perhaps attached to the premises. Further research seems to suggest that they were a firm of solicitors, holding the pub in administration. Ind Coope & Co. of Burton-on-Trent had acquired the Victoria by 1903, and their draught bitter and Burton Ale were still on tap in 1976 when CAMRA's *Real Ale in Gloucestershire* noted that it had a skittle alley with a large comfortable lounge.

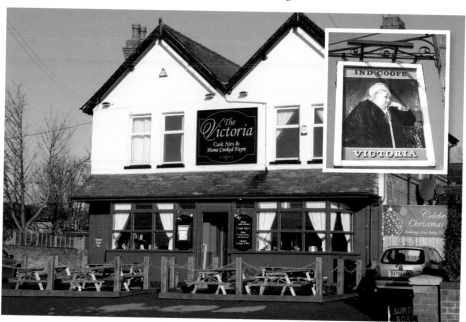

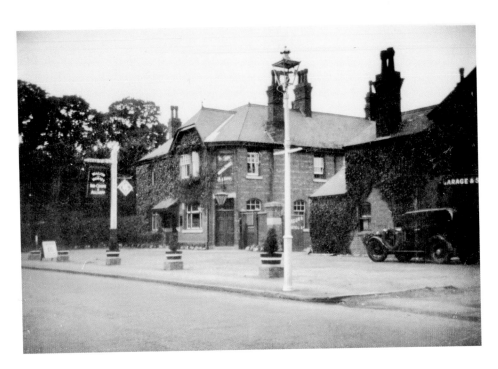

Waggon & Horses, Hucclecote Road, Hucclecote

During the 1930s, Arthur Saxby took over as landlord and converted the pub's outbuildings into stables for racehorses. Green Wheat was a winner at Cheltenham, but on another occasion, at Prestbury Park, disaster ensued when the horse fell awkwardly and killed the poor jockey. In the summer of 2001, as part of a £1.5 million refit to transform the pub to the Hucclecote Harvester, the original red-bricked building was covered in white cladding. In November 2007, the Sizzling Pub Co. took over, removed the cladding, and changed the name back to the Waggon & Horses.

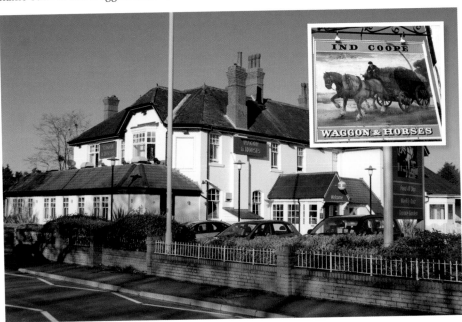

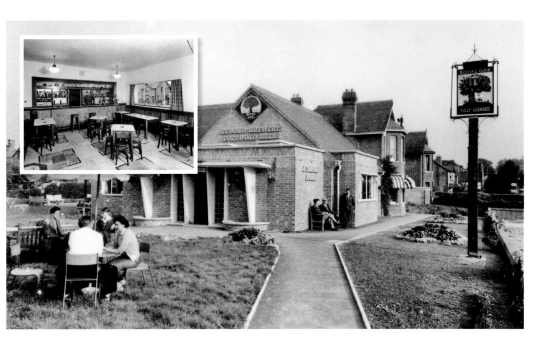

Royal Oak, Hucclecote Road, Hucclecote

The original Royal Oak was a stone built pub with a tiled roof, a rendered front, two small bay windows and a central entrance. In the 1920s it even boasted its own bowling green. In 1957, Stroud Brewery bought the house next door, Sunnybank, and the licence was transferred. The brewery built a large annex onto the house and the original Royal Oak was demolished to make room for a car park. In July 2004, Greene King of Bury St Edmunds, Suffolk, became the owners of the Royal Oak.

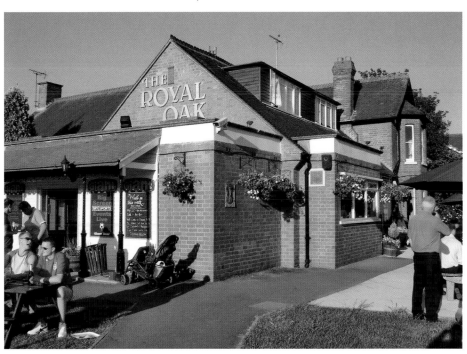

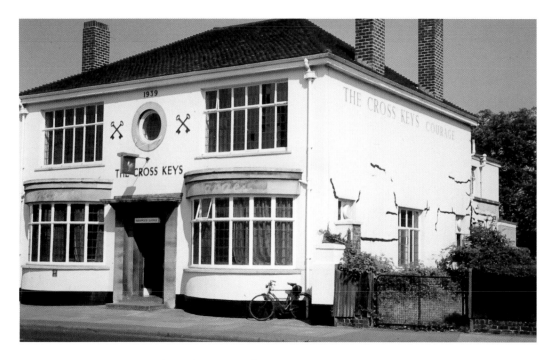

Cross Keys, Barnwood Road, Barnwood

The Cross Keys in Barnwood was completely rebuilt by Georges & Co. Bristol Brewery in 1939. It replaced an earlier inn that was owned by the Ashton Gate Brewery in Bedminster. Georges' took them over in 1931. Following the acquisition of the Bristol Brewery in 1961, the Cross Keys became a Courage pub. In March 1998, a massive gas leak under the nearby railway bridge could have caused an explosion. As a precaution trains were stopped and the road was closed while emergency services dealt with the leak – forty residents were evacuated to the Cross Keys Inn.

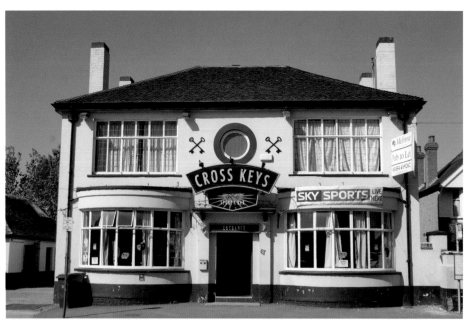

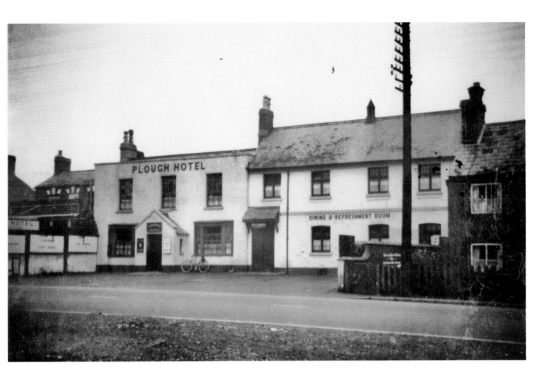

Friar Tucks, Bristol Road, Quedgeley

The Plough Inn/Hotel was owned by Arnold Perrett & Co. of Wickwar. When William Guilding held the licence at the beginning of the twentieth century, the Plough was popular with cyclists leisurely riding through the picturesque countryside from the city. The Plough Hotel changed its name to Friar Tucks in 1988, the new identity signifying the establishment was essentially a restaurant. Although there is a bar, Friar Tucks is still mainly food-orientated and now incorporates Joplin's Bistro. Bed and breakfast is also available.

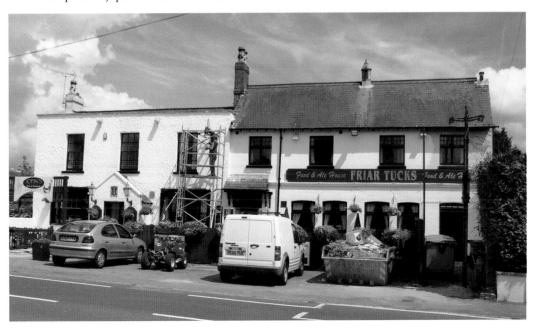

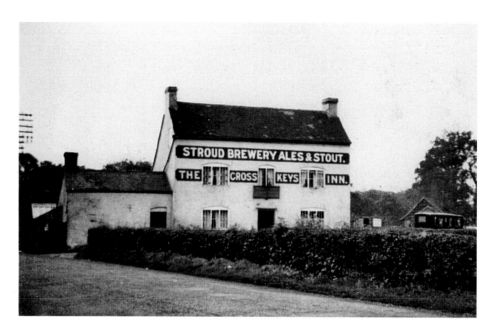

Cross Keys, Hardwicke

The Cross Keys was once leased to Godsell & Sons Salmon Springs Brewery in Stroud, before passing into the hands of the Stroud Brewery Company. It was described in the 1976 edition of *Real Ale in Gloucestershire* as an '18th century local with good food and atmosphere'. Whitbread PA was the beer on offer. Latterly owned by Enterprise Inns, Cross Keys closed in 2007 and the vacant property was put up for auction in March 2009. The building is now operating as a mobility shop, specialising in wheelchair-adapted vehicles.

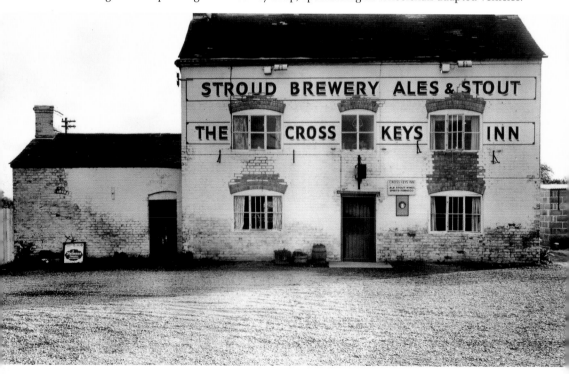

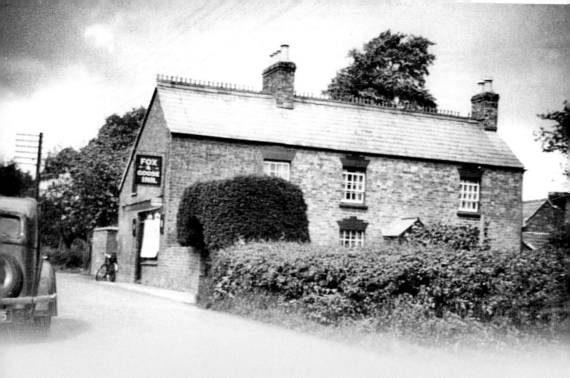

CHAPTER 3

Downstream From Gloucester

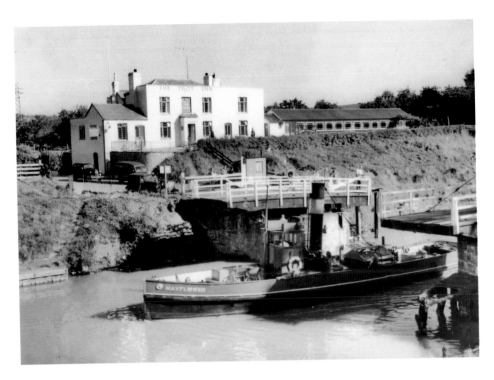

Pilot Inn, Sellars Road, Hardwicke

The Pilot Inn is on the banks of the Gloucester & Sharpness Canal to the east of Hardwicke. It became a popular attraction for visitors from Gloucester, who could arrive at the pub by boat and alight on a landing stage that had direct access to the pub's garden. Day trippers on the Gloucester & Sharpness Canal in the summer of 2006 were bemused to see red-eared terrapins on the banks of the canal, with a report of a 3-foot cayman alligator being seen chasing a duck near the Pilot Inn!

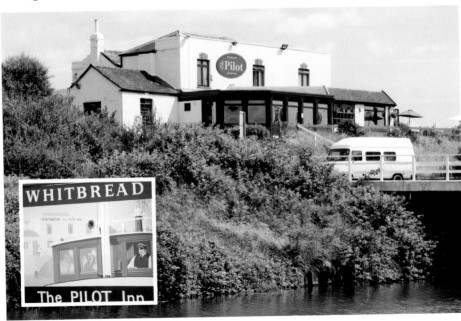

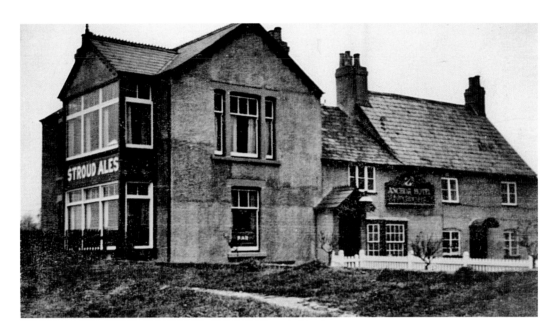

Anchor Inn, Epney

In late Victorian times, commercial breweries were actively seeking to expand their estate by purchasing pubs and smaller family breweries to gain more outlets. Ind Coope of Burton-on-Trent purchased the Gloucester brewery of Hatton & Co. (Northgate Street) in 1896 and acquired a few free houses, including the Anchor Inn on the banks of the River Severn at Epney. However, it seems that the Anchor did not fit into their portfolio, as it later passed into the ownership of the Stroud Brewery Company.

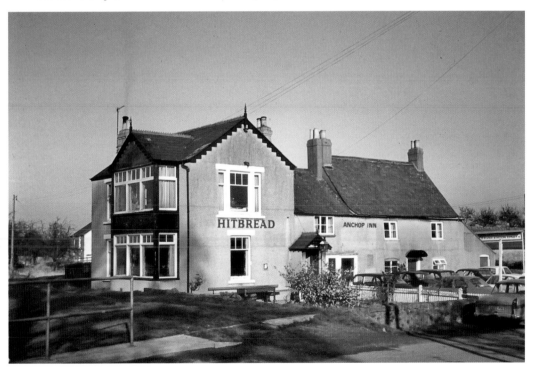

Darell Arms, Framilode

Sir William Lionel Darell, who died in 1883, was the Rector of Fretherne, 1844–78. The Darell Family lived in Fretherne House and had built up a sizeable estate. They even built a pub in the village and named it after the family! The Darell Arms, constructed in mock Tudor-style with two ornate gables, replaced the Passage House Inn that stood on the same site. Following the death of L. E. Darell in 1918, much of the family estate was sold off, but a small part was retained by Sir Lionel's son, Sir Lionel E. H. M. Darell, who died in 1954. The Darell Arms closed around 1990 and is now a private residence.

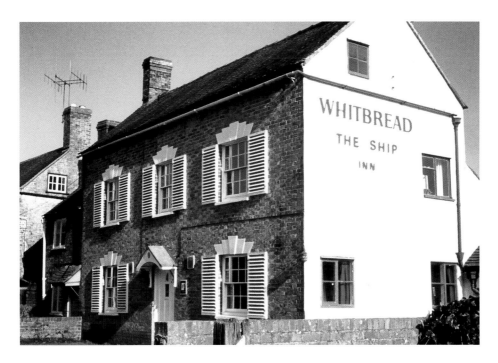

Ship Inn, Framilode

The Ship Inn is located on the banks of the old Stroudwater Canal at Upper Framilode. Although there are exciting plans to restore the Stroudwater Navigation from Saul Junction to Stroud, the short length of canal between Saul Junction and the River Severn at Framilode will never see the passage of boats again. Today, the only movement on the disused canal are ducks and swans, with glimpses of birds flying into the reed beds and rushes. Kingfishers have been seen here. The front garden of the Ship Inn is something of an ornithological haven.

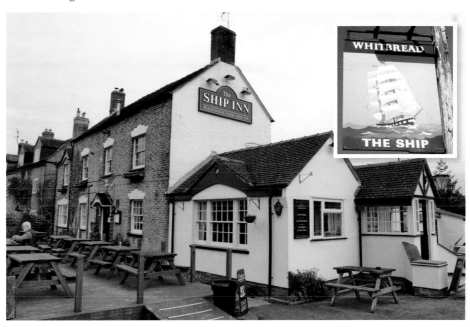

Bell Inn, The Green, Frampton on Severn

The Bell Inn is a quintessentially English country pub situated at the end of one of the largest village greens in England, extending to 22 acres. In July 1932, customers quietly supping their beer in the pub garden must have been surprised when the 776-feet *Graf Zeppelin* airship, the largest dirigible in the world, flew directly overhead. In more recent times, the building was taken over by an encroaching Virginia Creeper but this has now been removed to reveal the fine red-bricked Georgian frontage.

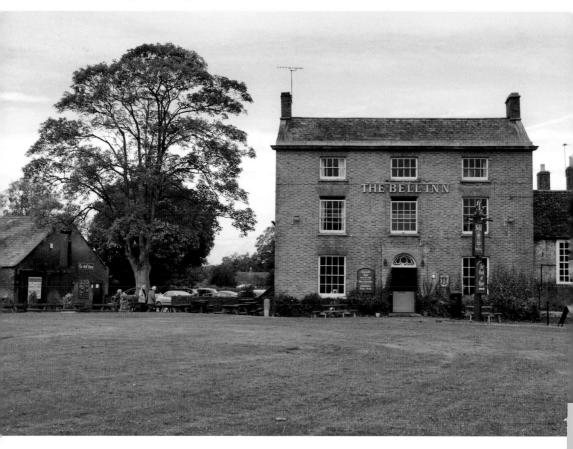

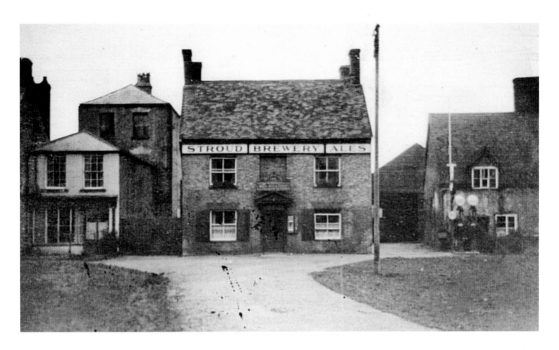

Three Horseshoes, The Green, Frampton on Severn

The village green in Frampton on Severn was the venue of the annual Easter elver eating contest where competitors would race to eat a pound in weight of elvers, or baby eels, in the fastest time. The custom died out in the 1980s because of the exorbitant price of the elvers. However, the locals at the Three Horsehoes revived the custom in 2003 – replacing the traditional elvers with spaghetti!

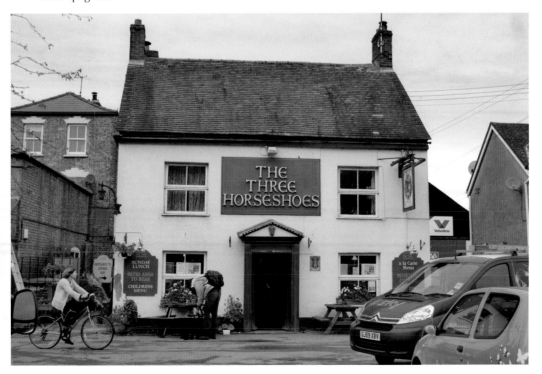

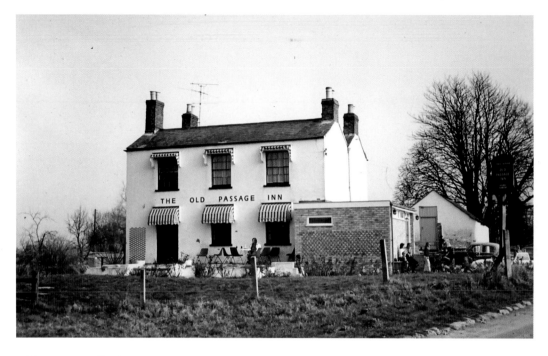

Old Passage, Arlingham

The Old Passage Inn, on the sweeping oxbow bend of the River Severn, was originally the New Inn. It was once owned by the Holford family of Westonbirt and became the Old Passage Inn in 1953. When the Old Passage closed in July 1999, it was feared that the pub might be converted to a private house but it reopened as a seafood restaurant in July 2000. Cornish native lobsters, served with a salad and side dish are the *pièce de résistance* at the Old Passage – don't ask for tomato sauce or salt and vinegar!

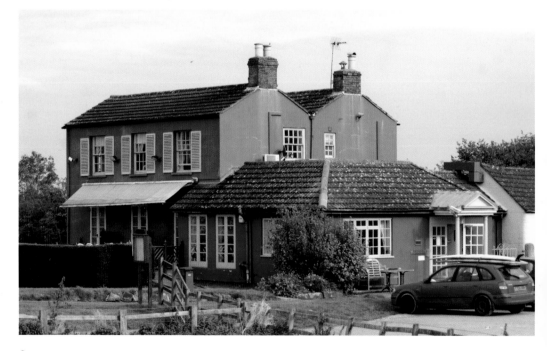

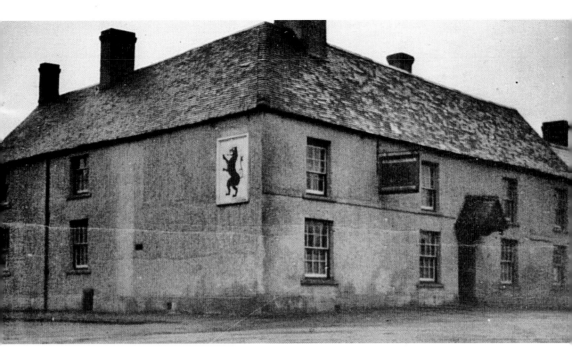

Red Lion, Arlingham

In 2003, head chef Jenny Waring created an annual Rook Supper, held at the Red Lion in late May, when traditional pies made with rooks and other game birds were served. Jenny had previously served up the dish at the Kings Arms in Didmarton. Diners came from far and wide to experience the tasty dish of Olde England. Landlady Janet Codner said, 'The rooks are born in May and I believe it is only legal to shoot them for two days. We had 150 from the Badminton House estate. Thankfully they came plucked.'

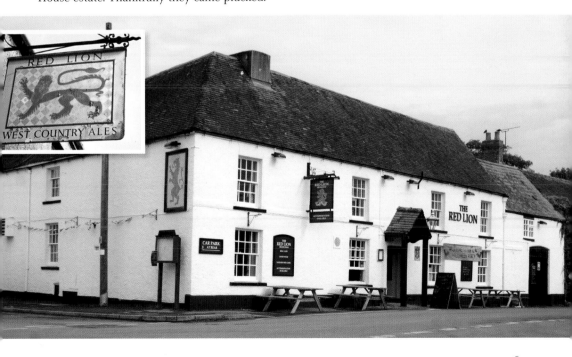

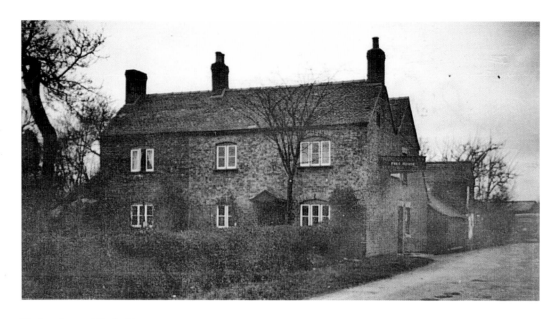

Tudor Arms, Slimbridge

The Tudor Arms is beside the Gloucester & Sharpness Canal on the road leading to the Wildfowl and Wetlands Trust. In the 1970s the restaurant adjoining the pub was called the Rorty Crankle Steak Barn and featured live music. The Rock family have been at the Tudor Arms for over forty years, apart from a three year break after Rita and Peter sold the pub in 2000 – only for Rita to repurchase it three years later. Today, their daughter Samantha is the licensee with her partner Richard. The Tudor Arms was named CAMRA Gloucester Pub of the Year in 2013.

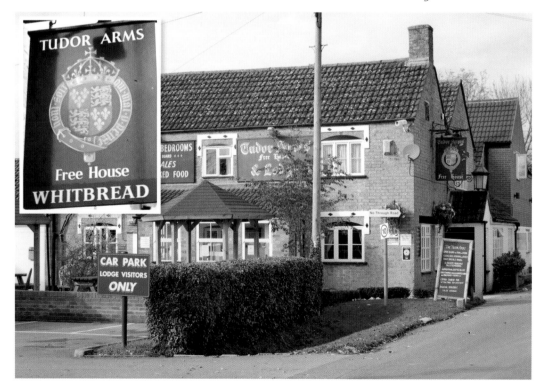

Apple Tree, Halmore

The Apple Tree Inn was one of the last true cider pubs in the country, finally closing in the mid-1960s. Charles Martell of the Gloucestershire Orchard Group recalls the Apple Tree Inn was furnished with bench seating and scrubbed wooden tables. George Summers was the owner of the Apple Tree Inn in 1891 and, until he sadly passed away a few years ago, Rodney Summers was still making award winning traditional ciders and perrys nearby in Slimbridge Lane.

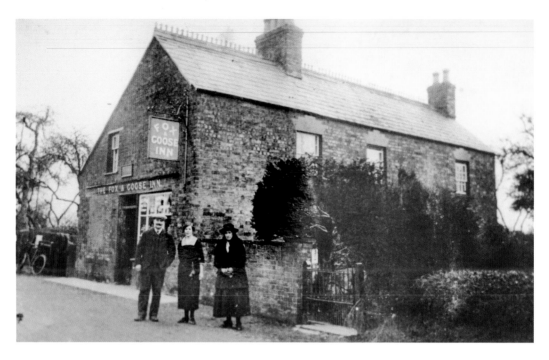

Fox & Goose, Halmore

The Fox & Goose was a nineteenth-century red-bricked traditional pub on the road leading to Purton. The 1980 edition of CAMRA's *Real Ale in Gloucestershire* described the Fox & Goose as a 'small, quiet roadside pub with only one bar. Not very salubrious but friendly.' Whitbread PA was on offer. The pub had closed by the end of the 1980s. The property has since been extensively modified and extended in recent years, and is now called Halmore House.

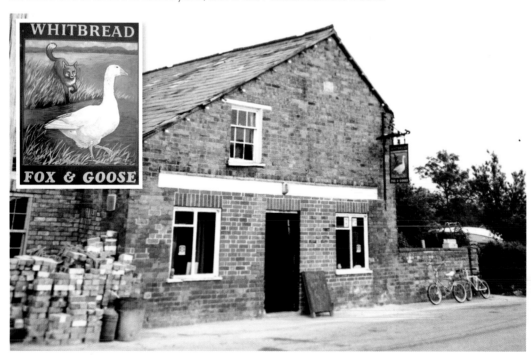

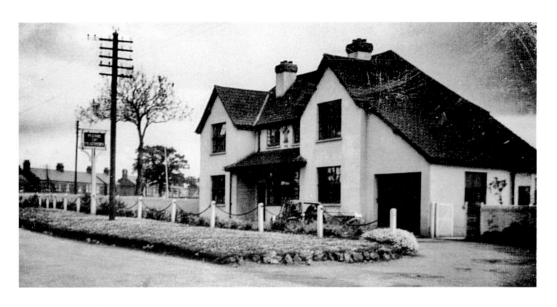

Lammastide Inn, Brookend

In 1934, Georges Brewery of Bristol built a new pub in Brookend and the license was transferred from the old Plume of Feathers on the east side of the road to the new premises around a quarter of a mile away. Charlie Meek, landlord in the 1940s, only had one arm, but rode with the local Berkeley Hunt and maintained a very fine rose garden at the front of the pub. Charlie's prize rose garden is now the pub car park! Lammastide is another name for harvest festival.

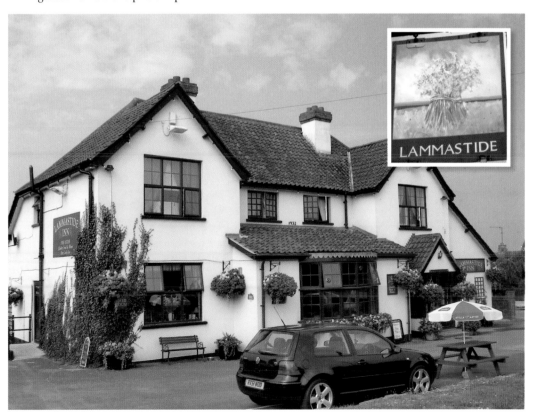

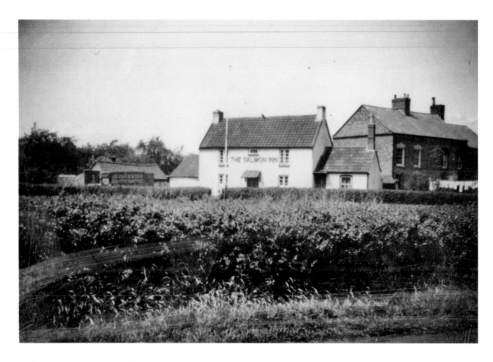

Salmon Inn, Wanswell

The sixteenth-century Salmon Inn was once a cider house, but had been acquired by the Wickwar Brewery by 1903. In December 1998, a family funeral reception held at the Salmon Inn turned into a full-scale brawl. The fracas was started by half a dozen guests, and escalated as feuding relatives intervened. At its height, thirty guests were involved in the fighting. Today, the Salmon Inn claims to be a proper traditional English pub with 'no music, dart boards or fruit machines, just atmosphere!' An animal farm at the pub has Shetland ponies, pigs, goats, rabbits, chickens and ducks.

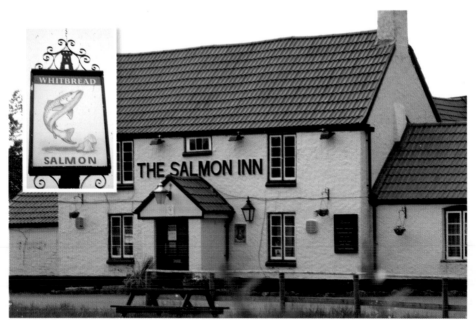

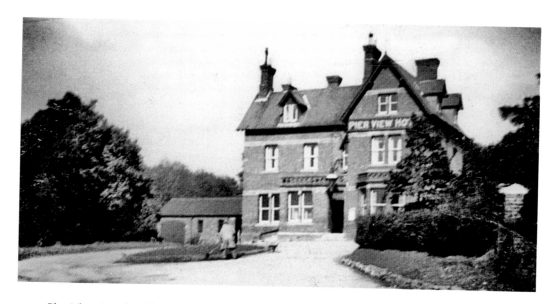

Pier View Hotel, Oldminster Road, Sharpness

In August 2010, staff, drinkers and guests at the pub took part in a reality show-themed spin-off called *I'm a Local Get Me Out Of Here*, which raised more than £2,500 for charity. The 'lucky' competitors spent three days and nights in the company of maggots, cockroaches, locusts and dung beetles. Visitors to the Pier View were able to watch the action from the 'base camp' on a live video link. The activities included sitting in a box of bugs and an unpleasant muddy assault course. Vince Carter was crowned 'king of the jungle'.

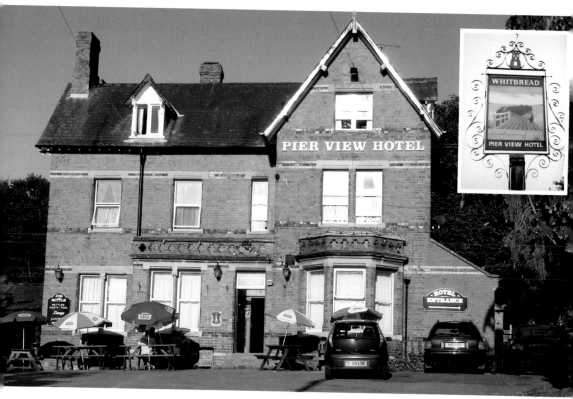

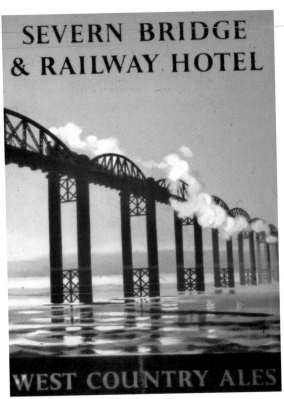

Severn Bridge & Railway, Sharpness
The Severn Bridge & Railway Hotel was named after the railway bridge that crossed the River Severn, half a mile to the north of the pub. The Severn Railway Bridge was 1,404 yards long and had twenty-one arches. It was partly demolished on a fateful night on 25 October 1960, when two oil tankers struck the bridge in thick fog after failing to navigate into the safety of Sharpness Docks. The Severn Bridge & Railway Hotel closed down sometime in the late 1970s/early 1980s due to lack of custom. It was converted to the Severn View Nursing Home.

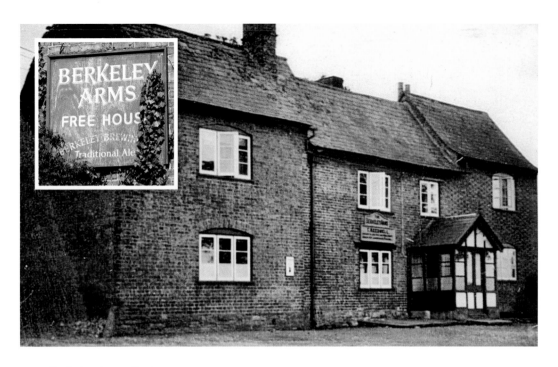

Berkeley Arms, Purton

The Berkeley Arms, a red-bricked pub on the banks of the River Severn, is a classic old-fashioned pub with a totally unspoilt interior. It is listed in the CAMRA National Inventory of Pub Interiors of Outstanding Historic Interest. A wooden sign on the wall of the pub still advertises the Berkeley Brewery, the microbrewery established at Bucketts Hill Farm near Sharpness by Dave McCredie in 1994. Tragically, Dave died in August 2000 when his brewery delivery van came off the road and hit a tree.

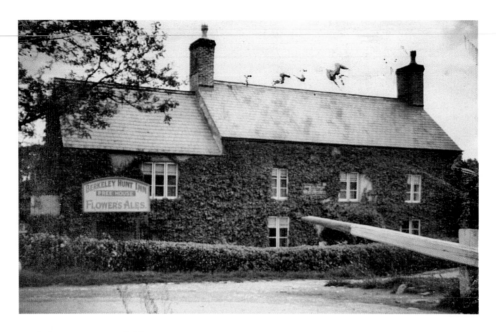

Berkeley Hunt, Canalside, Purton

The Berkeley Hunt was a classic unspoilt traditional canal-side pub, which sadly closed down in February 1998 when the Berkeley estate regained control of the property after the expiry of a twenty-five year lease. Often known as 'Mrs Musslewhite's' after a long serving landlady, the pub had a wooden panelled corridor with a serving hatch at the far end. The lounge was on the left and a small games room was to the right. The lounge doubled up as Mrs Musslewhite's private living space. Beer was drawn directly from the barrel.

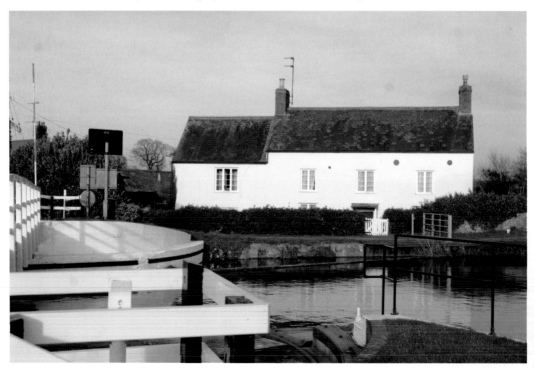

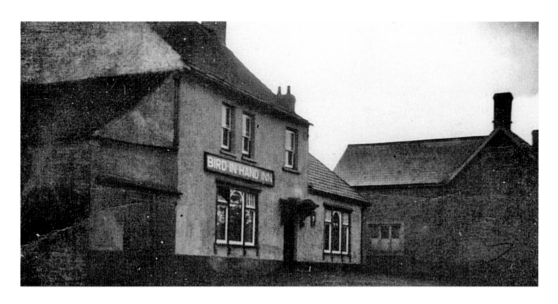

Bird in Hand, Marybrook Street, Berkeley

The *Gloucester Journal* reported on 10 March 1906 that the license of the Bird in Hand had been renewed, despite the fact that the 'sanitary arrangements were not adequate'. The Bird in Hand changed its name to the Malt House in 2000, when new owners Bob and Julie Moult took over. In recent years it has been refurbished and now includes 3 bars, a 100-seat restaurant and accommodation ... and the toilets are now excellent.

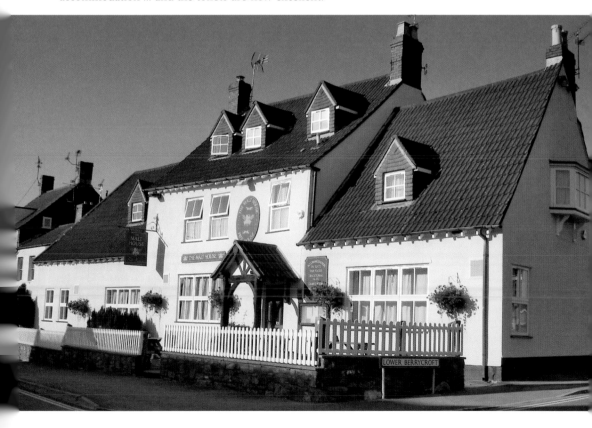

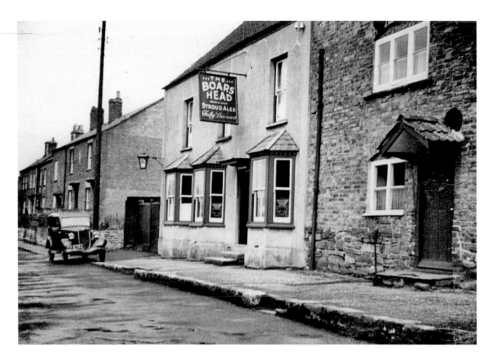

The Boars Head, Lynch Road, Berkeley

In 1903, the Boars Head was owned by Thomas Elvy's Dursley Brewery. When he went bankrupt in 1906, the pubs were acquired by Godsell & Sons of Salmon Springs, Stroud. On 18 September 1924, it was reported that the Boars Head was suffering decreased trade, which was accounted for by the reduction in hours, and a slump in trade at the nearby Sharpness Docks. The Boars Head has recently been through a period of changing fortunes, but was still trading when this book was being prepared.

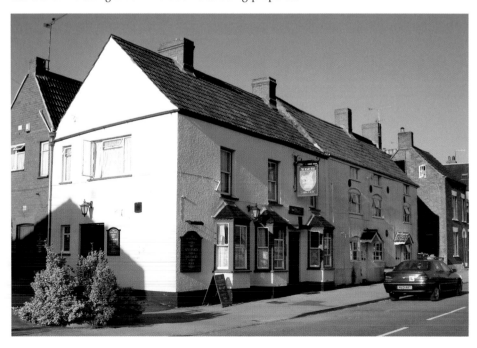

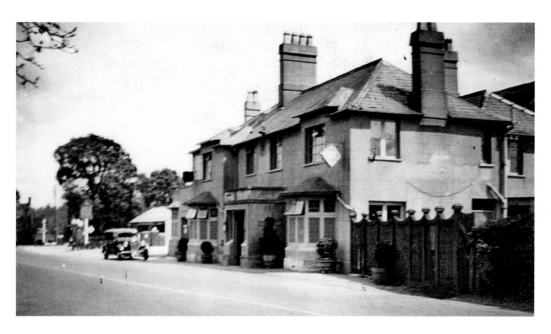

Prince of Wales, Berkeley Road

Berkeley Road is around 2 miles to the east of Berkeley on the A38. An advertisement in 1901 reads: 'Prince of Wales, Berkeley Road Station. Family and Commercial hotel. R. Holborow, proprietor. British and foreign wines, spirits and cigars. Horses and carriages let or hire.' The Prince of Wales Hotel is still trading and now boasts a conference centre for 200 delegates, with 43 bedrooms.

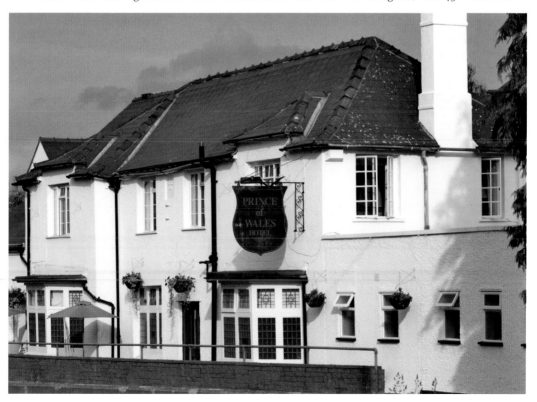

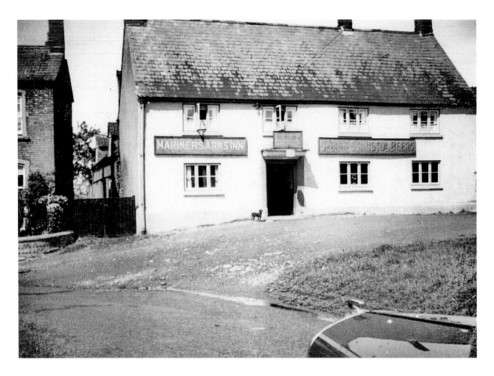

Mariners Arms, Salter Street, Berkeley

The Mariners Arms is reputed to be the oldest in Berkeley, dating back to at least 1476. The pub stands on the site of an early monastic building and there are two stone windows in the pub dating from around 1390, which were probably salvaged from the monastery. In the late 1990s, the Mariners Arms suffered a series of break-ins and one of the pub regulars, Steve Mould, volunteered to stay in the premises overnight to deter would-be burglars. Steve slept on a pub bench and stayed there for five years! Steve became something of a celebrity after he was dubbed 'Britain's Laziest Man' on BBC Radio 5 Live.

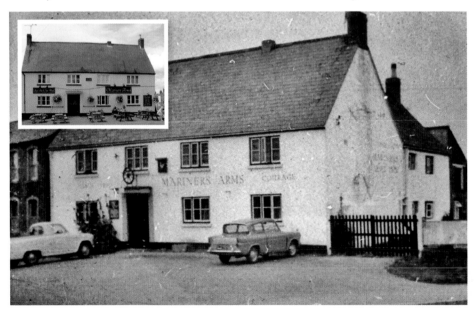

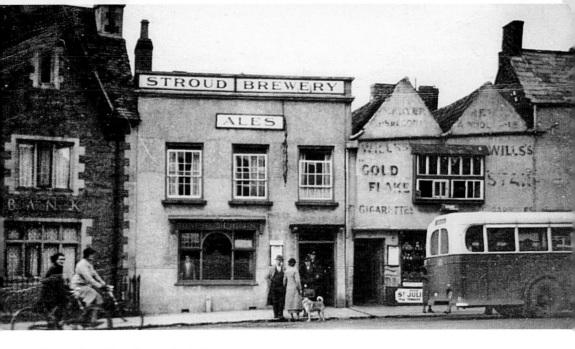

George Inn, High Street, Berkeley

The George Inn was located in the centre of Berkeley. It finally closed in 1990. The building traded as a furniture store before being converted to the Berkeley Pharmacy. The George Inn retains its West Country Brewery plaque and, remarkably, even the pub sign is still in situ. It is now a rendered building, but in Edwardian times it had a plain brick frontage. The tobacconist to the right of the George was once the Lamb Inn, which closed around 1906. J. C. Aldridge & Sons Ltd now occupies the site.

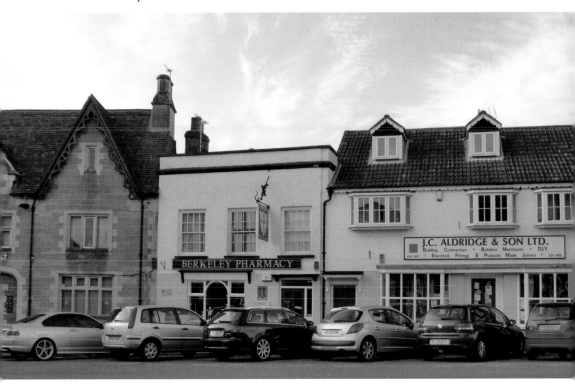

EAGLES BUSH BREWERY

Golden Eagle IPA

4.2% ABV

SALUTATION INN

Salutation Inn, Ham

The last decade has seen the Salutation Inn go from strength to strength, which is a remarkable achievement for a pub that is off the beaten track. When Steve and Sandra Fisher took over the tenancy of the Berkeley estate-owned pub in 2005, Steve installed a microbrewery on the premises (Eagles Bush). Following Steve and Sandra's retirement in 2007, Don and Sue Dunbadin took over the lease of the Salutation and immediately attracted the attention of the local CAMRA branch with their excellent selection of real ales. It was named 2010 CAMRA South West Pub of the Year.